Creative Oil Painting

First published in the United States of America by:
Quarry Books, an imprint of
Rockport Publishers, Inc.
146 Granite Street
Rockport, Massachusetts 01966-1299
Telephone: (508) 546-9590
Fax: (508) 546-7141

Distributed to the book and art trade in the United States by:
North Light, an imprint of
F & W Publications
1507 Dana Avenue
Cincinnati, Ohio 45207
Telephone: (513) 531-2222

Other distribution by:
Rockport Publishers, Inc.
Rockport, Massachusetts 01966-1299

ISBN 1-56496-323-3

10 9 8 7 6 5 4 3 2 1

Designer: CopperLeaf Design Studio, Inc.

Front cover images (clockwise from top left):
Grand Canal, Venice by Dean Larson
Still Life with Flowered Cloth by Joseph C. Skrapits
Paulson Children by Joanette Hoffman Egeli
Sunlit Lilacs, Peonies, and Roses by Sharon Burkett Kaiser

Additional images (title page):
Lilacs, Peonies, and Bachelor Buttons by Sharon Burkett Kaiser
Posts and Palazzos, Venice by Dean Larson

Printed in China

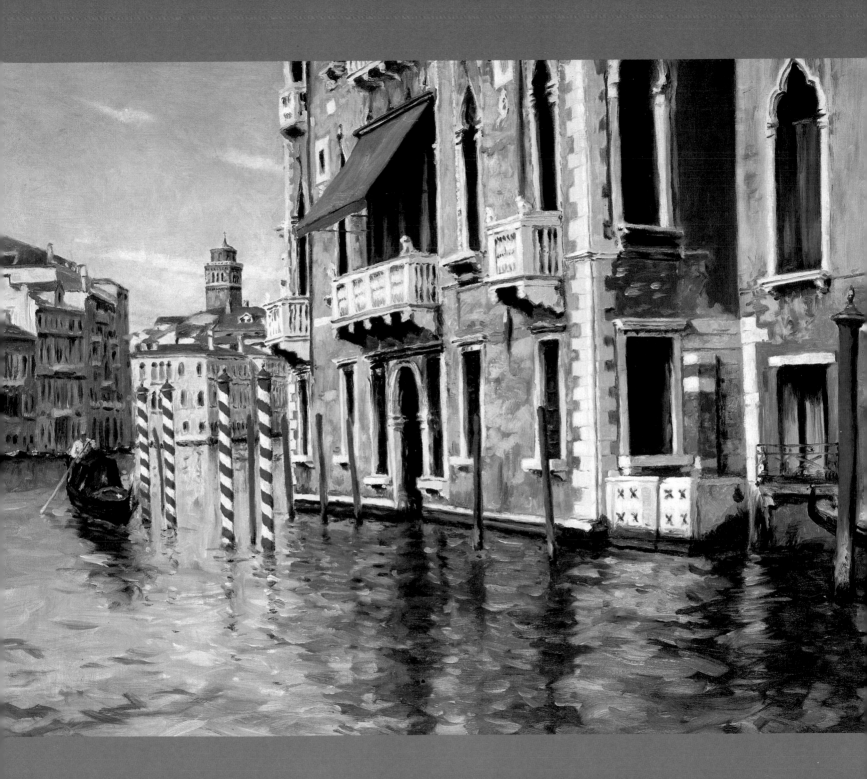

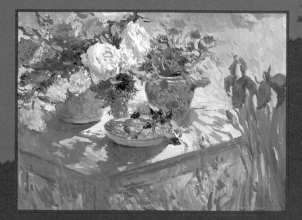

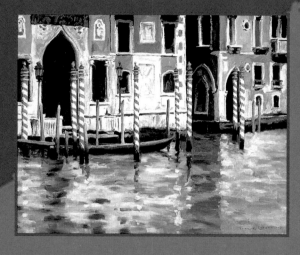

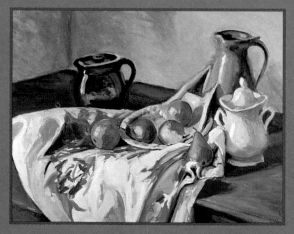

Creative Oil Painting

A Step-by-Step Guide and Showcase

M. Stephen Doherty

Quarry Books
Rockport, Massachusetts

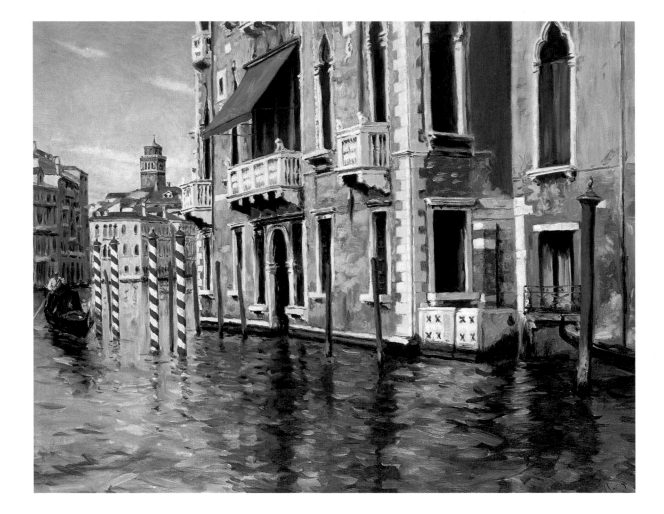

Acknowledgments

Everyone who creates artwork hopes that the saying "Life is Short. Art is Long" will hold true for them. We all want to preserve what we have been given by those who taught us, inspired us, and supported us; and we hope to leave behind something of our own that will be noticed and appreciated by those who come after us. The artists featured in this book certainly have those ambitions, and it has been my pleasure to write about the things that matter to them. I thank them for taking time away from their busy careers to provide the material I requested. I hope the book helps to extend their influence to other artists and other times.

I also want to thank the people at Rockport Publishers who gave me the opportunity to write the book, and who lent their talents to the editing, design, and production of the book.

Finally, I want to acknowledge the people who mean the most to me: my wife, Sara, and my children, Clare and Michael. Without their love, none of this would matter to me.

CONTENTS

ℐNTRODUCTION

When you hear a group of artists talking to each other, much of the conversation is likely to be about materials and techniques. You might hear that one artist has just discovered a new painting surface that is lightweight and inexpensive, another has learned something new about Cézanne's palette from viewing an exhibition of his work, and a third recently changed her painting medium and feels it has given her work a whole new direction. You'll likely conclude from these conversations that supplies and procedures are quite important to almost all practicing artists, and of course, you'd be right. Painters are always searching for things that will make their work better, easier, or different from the work they've done before. Of course, materials and techniques are not an artist's only or most important considerations. Indeed, subject matter and style are perhaps the keys to the expression of an artist's ideas and emotions. But without the tools and appropriate materials, those ideas and expressions will never be conveyed.

In the process of searching for information about materials and techniques, oil painters are constantly reviewing the fundamental characteristics of paints, brushes, supports, and mediums. It seems appropriate, then, to begin this book by reviewing those characteristics. Whether you are attempting your first oil painting or your five-hundreth, it is useful to keep in mind the components of the paint, the variety of surfaces, the formulations of mediums, and the shapes of brushes. That information will certainly help you judge the significance of the various palettes, materials, and procedures used by each of the artists featured in this book.

𝒫aints

Oil paints are most commonly made from the ground pigments that give the colors their names, plus linseed oil and various fillers. Some companies add fillers to extend the pigment, make the paint flow smoothly, or adjust the drying time. Other manufacturers use no fillers at all.

The quality of an oil paint depends on the quality of the ingredients and the percentage of oil and fillers. A high-quality paint is one that is likely to have a better, more expensive, and more finely ground pigment; a superior grade of linseed oil; and a small percentage of filler, if any at all.

Some pigments produce a paint that is transparent (such as cobalt blue), while others are opaque (such as chrome green oxide). Some pigments are not lightfast and therefore may fade in the presence of ultraviolet light, while others are lightfast and permanent. Most major paint manufacturers put labels on paint to tell you the pigments used to make the paint, their light-fast rating, and whether the pigment is transparent or opaque. Not all of the artists featured here list their preferred brand of oil paint in the palette section. Where the painter does not mention a preference, Winsor & Newton and Sennelier oil paint colors have been used.

Brushes

Oil-painting brushes are made from a variety of natural and synthetic hairs gathered together in a particular shape. Bristle hairs are the most popular material for making oil-painting brushes because they hold a large amount of paint and respond to pressure from the artist's hand. For painting fine details or applying thin glazes, oil painters usually prefer a soft-haired sable or ox-hair brush.

The most popular shapes are round (pointed tip), flat (flat top), filbert (tapered tip), bright (similar to a flat but with shorter hairs), and badger (fan-shaped).

It is essential that brushes be thoroughly cleaned before they are put away. After rinsing out the oil paint with turpentine or paint thinner, you should use a brush-cleaning soap to clean, soften, and restore the brush hairs.

Solvents and Mediums

Solvents are used to thin the oils when you're painting or to clean the brushes. You'll notice that most of the artists featured in this book begin their painting process by blocking in their pictures with paint that has been thinned to a consistency of cream. Although turpentine has traditionally been the most popular solvent for thinning paint, mineral spirits or paint thinner actually do as good a job, are less expensive, and have a less offensive odor than turpentine.

A number of the featured artists use a medium to make their oil paint more transparent and fluid without making it runny; other artists add a medium that thins the paint and speeds up its drying time. The most traditional painting medium is made by combining one part turpentine (in this case, mineral spirits won't work), one part linseed oil, and one part damar varnish. Alkyd painting mediums speed up the drying time of the paint while making it more transparent and fluid.

Supports

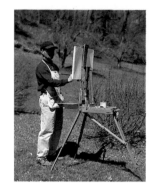

The author uses a half French easel, which can be folded into a small box for easy carrying.

The most popular surfaces on which to paint oil colors are cotton canvas, linen canvas, and wooden panels. No matter which of these materials is used, the artist must coat it with something to prevent the linseed oil in the paint from reaching the fabric or wood. Without protection, the linseed oil would likely cause the support to deteriorate.

Sealing and priming the supports also makes them smoother and less absorbent. If the priming material (gesso or paint) is mixed with oil color, the support is said to be toned.

Varnishes

Varnish gives a uniform glossiness to a painting and will protect the surface from the damaging effects of dust, grease, water, and any other material that might land on it. Retouch varnish can be used during the painting process or immediately after the picture has been completed. All other varnishes are applied after the oil paint has thoroughly dried (usually a minimum of six months to a year). For obvious reasons, you want to use a varnish that can be removed from the surface of a painting without damaging the oil paint underneath it.

When painting outdoors on a stretched canvas, block the sunlight from coming through the canvas and causing a distracting silhouette.

Furniture and Lighting

There is a wide range of furniture made for working outdoors or in a studio. As you might expect, the outdoor equipment is made to be lightweight, compact, portable, and sturdy. Several popular outdoor easels, paint boxes, and carrying cases are shown on the following pages.

It is usually best to work with the painting surface turned away from the sun, so the brush won't cast a shadow across it, as shown here.

Outfitting a studio is like buying furniture for a home. One can get by inexpensively by adapting cast-off chairs, tables, and cabinets, or one can acquire deluxe furnishing such as a pneumatically driven easel, electrically powered drafting table, or solid oak taboret. The choices are based on your budget, the scale of your paintings, your personal need for conveniences, and the space available in your studio.

Many artists have strong opinions about lighting. Some insist on using only natural light entering through a north-facing window, while others mount color-corrected lights above their work area so they can paint under uniform conditions at any time. Many art supply stores and direct-mail catalogs sell these artificial lights.

A pochade box makes it easy to carry paints, brushes, and prepared panels out on location. This box was handmade by the Open Box M Company of Wyoming.

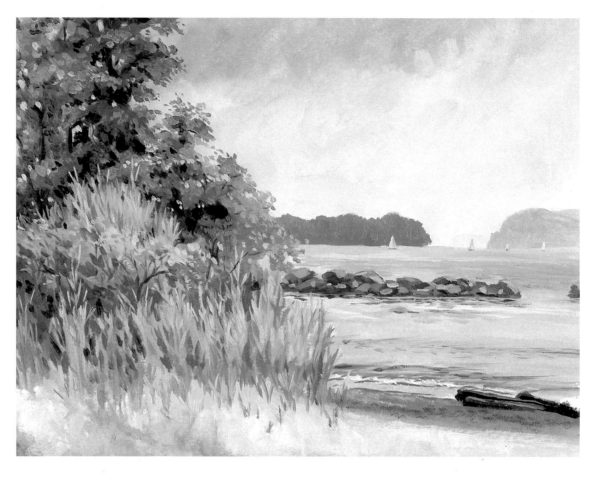

M. Stephen Doherty
Father's Day on the Hudson
Oil, 11" x 14"
(27.9 cm x 35.6 cm)

M. Stephen Doherty
Ravenna House, Natchez
Oil, 11" x 14"
(27.9 cm x 35.6 cm)
Courtesy Bryant Galleries,
New Orleans, Louisiana

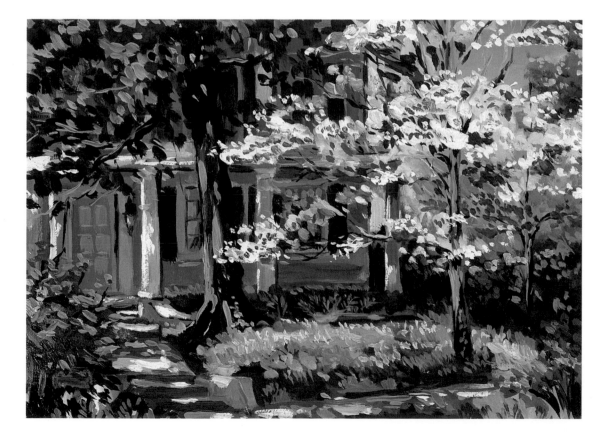

SECTION

1

STILL LIFES

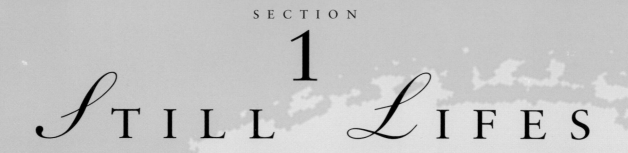

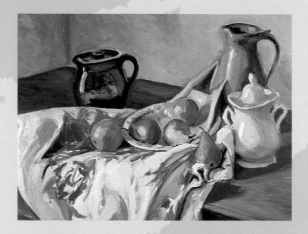

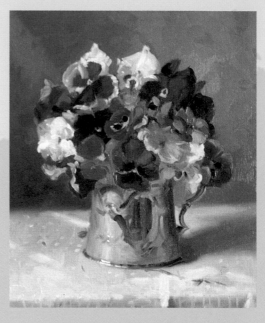

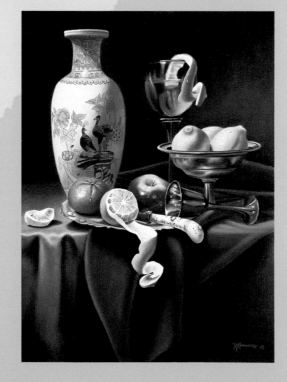

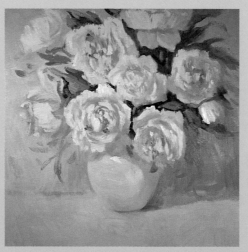

*S*till-life painters can exercise the greatest amount of control over their subject matter and painting conditions. If they choose, they can leave an arrangement of objects set up under constant lighting conditions for weeks, months, or years—however long it takes them to complete the picture. Of course, they may add perishable fruits and flowers, and they can set the display outside under variable lighting and weather conditions, but they are never forced to deal with an impatient model or an approaching storm. The advantage of having this control is that the oil painter can take time to consider the subtle spatial relationships between forms, change the intensity and direction of light to alter the pattern of shadows, and suggest the meaning of an object's function or identity. All of this can be done in a quiet studio where no one else will disturb the creative process.

William Yenkevich and Joseph C. Skrapits take complete control of their painting conditions so they can develop their oil paintings carefully, deliberately, and methodically. In contrast, Randall Lake and Sharon Burkett Kaiser work against the clock by making perishable flowers and fruits the main subjects of their pictures. They give up some control in order to suggest the transient, delicate character of their subjects.

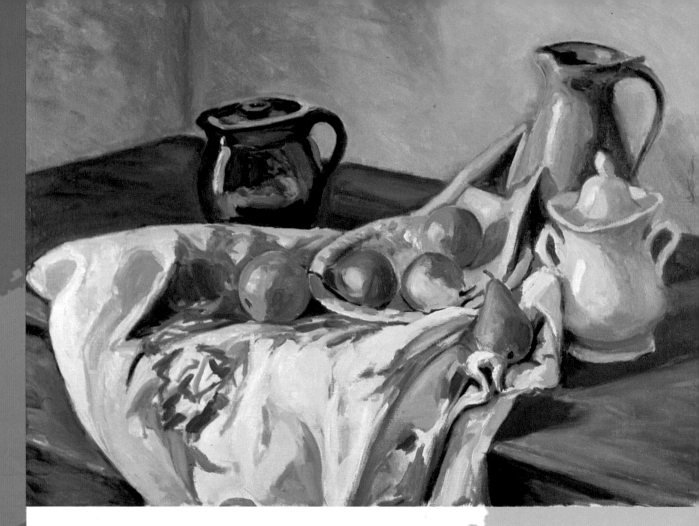

Still Life with Flowered Cloth

Oil, 20" x 27"
(50.8 cm x 68.6 cm)

Artist and writer Joseph C. Skrapits began painting in 1985 as a pupil of renowned Italian-American artist Antonio Salemme. He broadened his foundation with intensive study of French Impressionist methods, traveling to Giverny, Moret-sur-Loing, and Aix-en-Provence. Skrapits has taught courses in still life and plein air landscape painting. His works are in numerous individual and corporate art collections.

Creating the Illusion of Form

F or most of the twentieth century, oil painters have been intrigued by the possibility of creating illusions of weight, volume, and space within a flat, rectangular piece of canvas. And of all the possible subjects that lend themselves to this kind of exploration, still lifes are certainly one of the most popular. The simplest combinations of colors, brush strokes, and layers of paint can make a bowl look round, a table seem solid, or a cloth appear flowing even though the observer sees nothing more than layers of oil paint on a two-dimensional surface.

Pennsylvania artist Joseph C. Skrapits recently spent time in France visiting historic painting sites and looking at a large collection of works by one of the masters of still-life painting, Paul Cézanne (1839–1906). The experience helped him gain a greater understanding of how an artist can create these seemingly magical illusions.

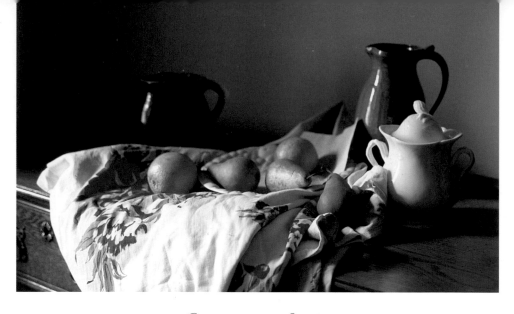

Getting Started

To demonstrate what he learned from Cézanne, Skrapits arranges a group of traditional still-life objects—simple ceramic pitchers and bowls, pears, oranges, and a piece of cloth. He avoids using flowers or plants that would change color or shape during the week it takes to complete the painting.

The objects are organized on top of a wooden table near a window, with each piece placed so that it touches at least one other object. Skrapits positions his easel at an angle to the table so the table's front edge as well as the line of the draped cloth leads the viewer's eye through the composition. That is, the tabletop seems to move diagonally from the lower right side of the picture to the middle left, and the cloth seems to flow in the opposite direction.

Skrapits considers using spotlights as a constant source of illumination, but instead decides to use the softer, warmer light from the window to reveal the objects. "Artificial light often causes the illuminated areas to be cool while the shadows become harsh," he explains. "Natural light gives more warmth to the highlights and depth to the shadows."

Palette

Skrapits uses the same Sennelier oil paints that were originally formulated for Paul Cézanne in the 1890s. They are somewhat stiffer than other brands and include unusual colors like peach black and Chinese orange.

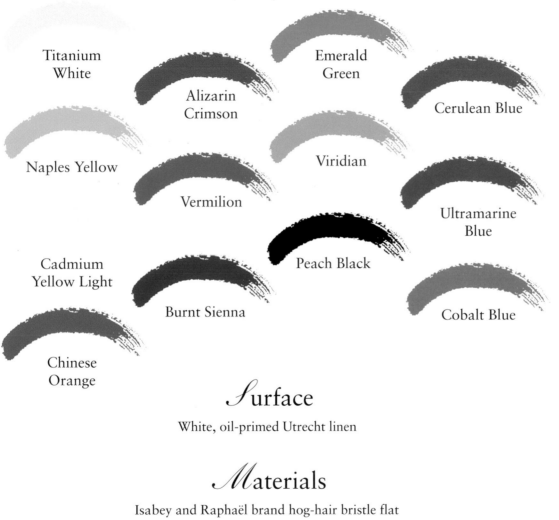

Titanium White

Alizarin Crimson

Emerald Green

Cerulean Blue

Naples Yellow

Viridian

Vermilion

Ultramarine Blue

Cadmium Yellow Light

Peach Black

Burnt Sienna

Cobalt Blue

Chinese Orange

Surface

White, oil-primed Utrecht linen

Materials

Isabey and Raphaël brand hog-hair bristle flat
and round brushes, sizes #2 to #10
Round mongoose brushes (to glaze colors and to paint details)
Mineral spirits
Disposable paper palette

Painting
Still Life with Flowered Cloth

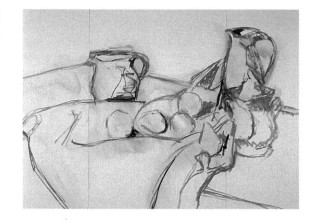

1 To locate important elements of the picture, Skrapits draws two pencil lines, dividing the canvas vertically: one inset 20 inches from the left canvas edge, the other inset 20 inches from the right (the distance is equal to the height of the canvas). Then, he draws the still-life objects with a thin round brush and a dilute mixure of ultramarine blue and peach black.

2 Using the same thinned paint, the artist blocks in the shadows and value contrasts. These tones are easiest to paint accurately with shades of black and gray; the actual colors of the objects—often called the "local colors"—can be applied later, once the first applications of paint are dry.

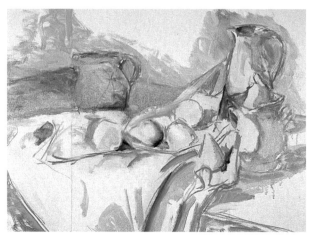

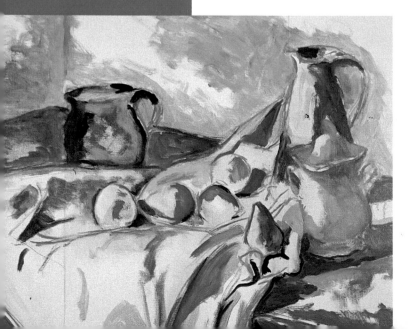

3 Adopting a technique used by Cézanne, Skrapits adds neutral tones to the still life with dilute mixtures of brown-gray and blue-gray paint (varying amounts of burnt sienna and ultramarine blue added to titanium white). Again, this application must dry before any more painting can be done.

4 Brush strokes of cerulean blue, Naples yellow, emerald green, and titanium white establish the green and blue tones in the background, shadows, and pitcher. Notice how the contrast between these cool colors and the warm tones added in the next step begins to create the appearance of volume.

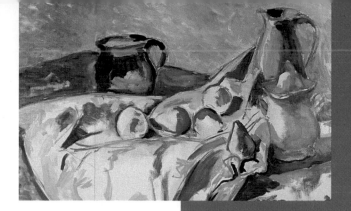

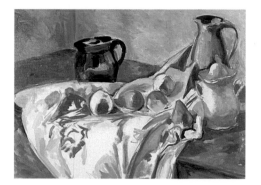

5 Now, Skrapits adds warm oranges, reds, and brown-reds. He paints the fruit, tabletop, cloth, and background with mixtures of Naples yellow, burnt sienna, alizarin crimson, and vermilion tinted with titanium white. The picture begins to stir with life as the warm light brings out the three-dimensional appearance of the forms.

6 The artist raises the intensity of color, working increasingly thicker mixtures of paint over the canvas. He also paints the brightest parts of the pears and establishes the patterns and folds of the cloth. Because oil paint remains wet for several days, an artist has time to rework areas and to create soft edges and blended tones.

Inset: More titanium white and several closely related tints of white (made with both cool and warm colors) emphasize the draped cloth. The artist positions highlights on the crockery and fruit so they sparkle with life. Blue and yellow reflections define the glossy surface of the black pitcher.

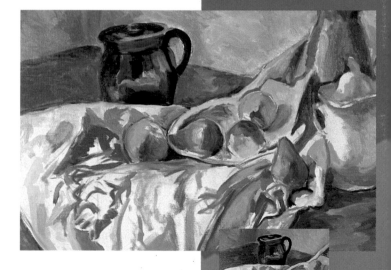

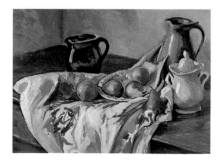

7 With sweeps of a large, clean bristle brush, Skrapits pulls paint from one area to another across the background wall. These strokes simplify and unify the areas of light and shadow. He wipes the brush clean and pulls it across the area of the tabletop, then repeats the process to unify the tones in the cloth. Skrapits reestablishes a few details with a small brush, and the painting is finished.

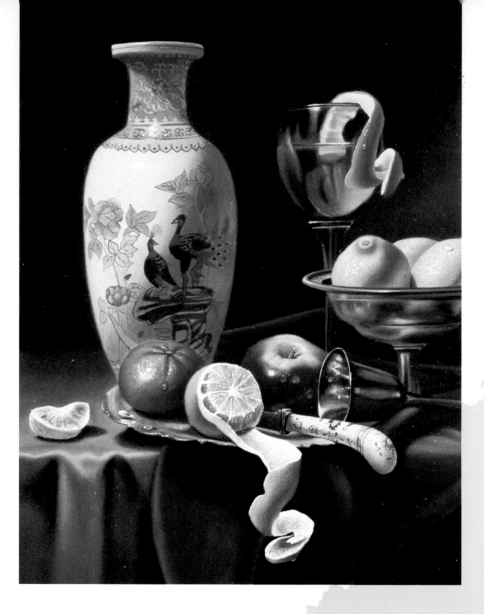

Scent of Elegance

Oil, 20" x 16"
(50.8 cm x 40.6 cm)

Although William Michael Yenkevich attended the Columbus College of Art and Design
in Columbus, Ohio, he is primarily self-taught. Since 1979, he has been teaching at the
Hazleton Art League in Hazleton, Pennsylvania.

Fooling the Eye with Precision

Oil paints can be used to create extraordinary illusions, and from the Renaissance until today, artists have been intrigued by perpetrating visual deceptions. In the sixteenth century, for example, Italian and French artists painted the walls of palaces to resemble exotic woods and colorful marbles. Seventeenth-century Dutch artists produced such believable still lifes that viewers almost thought the flowers had fragrance and the fruit was about to spoil. And several nineteenth-century American artists painted trompe l'oeil ("fool the eye") still lifes in which objects seemed to rest inside a box.

To create such convincing illusions, the artists had to understand techniques for handling linear and atmospheric perspective, compositional design, relative value, local color, and natural illumination in addition to the procedures for working in oil. The training that made it possible for those artists to acquire their skills is not readily available today, but a few artists have educated themselves by studying the Great Masters. Pennsylvania artist William Michael Yenkevich is one such artist, and he has been teaching others what he has learned through study and observation and perfected through practice.

Yenkevich makes small pen and ink sketches from memory.

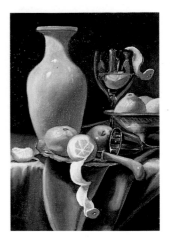

A small grisaille study of the still-life arrangement.

Getting Started

Yenkevich has developed a laborious and time-consuming set of procedures for planning and executing his oil paintings. He begins by making small pen and ink sketches from memory of still-life objects to establish the best arrangement of and relationship between the shapes, center of interest, and rhythms within a rectangular space. Once he settles on a design, he makes a larger pen and ink drawing that becomes his guide for setting up the actual objects and establishes the main theme of the painting.

Yenkevich then makes a small grisaille study of the still-life arrangement on an 11" x 9" (27.9 cm x 22.9 cm) panel using ivory black, flake white, and a touch of raw umber oil paint. This gives him another opportunity to study the composition of light and dark values and plan how to paint the picture. Other meticulous methods that he uses include drawing and transferring a cartoon the size of the intended picture, underpainting dark and light values, underpainting forms and values, and overpainting glazes and scumbles of oil color.

Palette

To have fresh oil paints, Yenkevich makes them himself by grinding pigments with a muller and mixing them with cold-pressed linseed oil. He prepares the colors before each painting session.

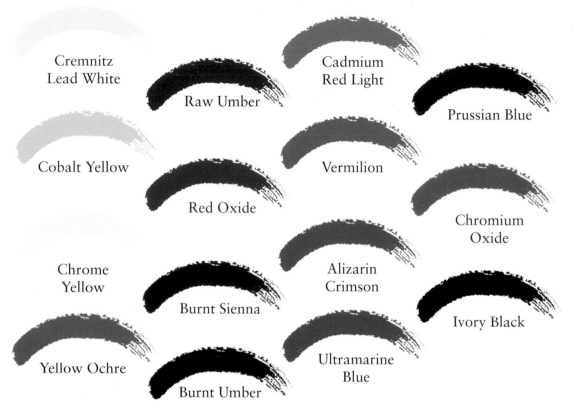

Cremnitz Lead White

Raw Umber

Cadmium Red Light

Prussian Blue

Cobalt Yellow

Red Oxide

Vermilion

Chromium Oxide

Chrome Yellow

Burnt Sienna

Alizarin Crimson

Ivory Black

Yellow Ochre

Burnt Umber

Ultramarine Blue

Surface

Lightweight canvas glued to veneered hardwood panel

Materials

Soft-haired sable, camel, squirrel, or badger brushes (with bristle brushes to cover large areas)
Flats, rounds, and filberts (depending on the section he happens to be painting)
Fine cheesecloth (to dab a thin glaze of color over a large area of the canvas)

Painting
Scent of Elegance

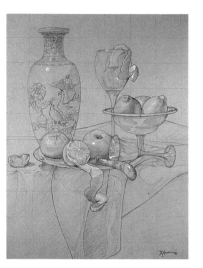

1 To become even more familiar with the elements of the picture, Yenkevich makes renderings of individual and grouped objects using Conté pencils and white chalk on a piece of toned paper that has the same proportions as the intended painting. The detailed drawings help him to solve any remaining problems about light and dark masses, proportions, perspective, and values.

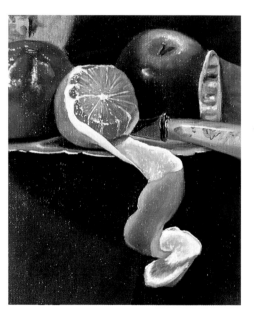

2 In further preparation, Yenkevich makes detailed oil studies of parts of the still-life arrangement on 9" x 6" (22.9 cm x 15.2 cm) panels. He uses a direct alla prima technique so he can study objects that might present problems later. In this study, he is studying the perishable fruit that will change its shape and color while he is working on the painting.

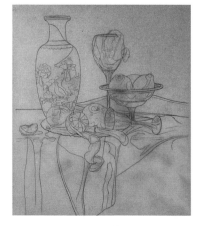

3 Now the artist prepares a full-scale charcoal and graphite cartoon drawing of the still life. He transfers the lines of the picture directly onto the gray-toned canvas by rubbing chalk on the back side of the cartoon, laying the drawing over the canvas, and tracing the lines with a sharp pencil. He then redraws the chalk lines on the canvas with sepia-colored ink to make them permanent.

4 Establishing the preliminary underpainting involves painting the dark areas with sepia ink and then painting the light values with lead white oil paint. This illustration shows what the panel looks like after both stages have been completed. Yenkevich believes that this process gives him a foundation to set up thin darks and high-key lights with the depth and beauty found in Old Master paintings.

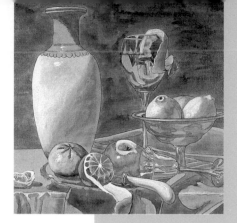

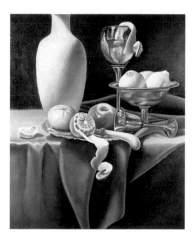

5 Adding a small amount of the local color to a gray value, Yenkevich begins to establish and modify the objects' forms and values. He thins the paint with a medium made from triple-rectified turpentine, stand oil, Venice turpentine balsam, and a drop or two of cobalt drier, which yields a hard, enamel-like surface on the painting. He allows each thin layer of paint to dry before applying the next.

6 Yenkevich applies local color by glazing and scumbling the paint, slowly building up the thin layers of color to create interwoven layers of transparent, translucent, and opaque color. At times, he heightens the whites with either egg tempera or oil paint, avoiding direct mixtures of cold and warm colors to preserve the luminosity of the color.

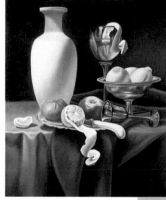

Completing the Painting

7 As Yenkevich adds decorative details to the vase and more local color to the tablecloth, he evaluates the overall composition. "I constantly keep in mind the three color dimensions: value, hue, and intensity," he says. "I also remember the three types of color: local color, light-source color, and environmental color."

Yenkevich adds more details and highlights, modifies the color and shading, and applies a glaze of crimson over the red velvet cloth. He applies subtle glazes of color over the depiction of other objects to lend emphasis and unity to the picture. He adds final accents and details to heighten the sense of dimension, and the painting is finished.

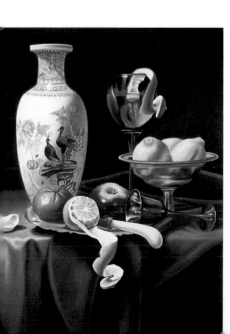

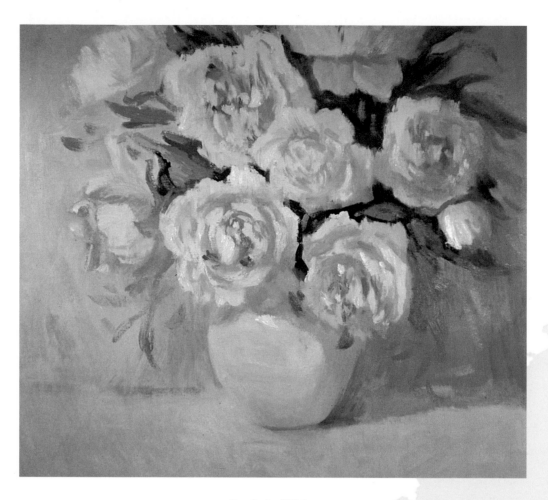

Study in White

Oil, 24" x 24"
(61 cm x 61 cm)
Private collection

*Sharon Burkett Kaiser, a graduate of California State University at San Diego, studied painting
with the renowned Russian-born artist Sergei Bongart. She has studied at the California
Institute of Art and at California State University at Northridge, and privately with
instructors from the Art Center College of Design.*

Observing the Fragrance of Color

*I*n oil painting, color and light give life to a human figure, drama to a skyline, beauty to a rose, and depth to a meadow. There are as many ways of handling color and light as there are artists holding brushes; no one way is right or wrong. However, the artist must understand how color and light affect the perception of form and space, and how they can be controlled to express what is most important.

Californian Sharon Burkett Kaiser is internationally known for her sumptuous floral still lifes, but above all else, she considers herself a colorist. Kaiser explains that understanding the perception of color requires an understanding of the way light reveals value and hue. She says, "When I think about an object's color, I keep in mind all the elements that may affect my perception, such as the lighting conditions, the colors of the objects near it, and the atmosphere."

The artist's palette arranged in a U-shape around the paint mixing area.

Getting Started

Kaiser lays out her complete palette of colors in a U shape around the central mixing area, placing the colors in the same locations so she can automatically pick them up with her brush. "I know my palette as well as musicians know the keys on their instruments," Kaiser explains. "My hands know exactly where the colors are because I always put them in the same place." She mixes her own greens and doesn't work with earth colors or with black, preferring clean, strong colors.

Although Kaiser enjoys doing quick landscape paintings outdoors, she almost always does her still lifes in her studio or on the deck of her seaside home. Within her studio, she has a variety of light sources with which to illuminate her subject. She can place the objects near the windows where they will capture direct sunlight, under the skylights where a softer light descends from above, near artificial lights that yield warm tones, or in places where there is a combination of those lights. She always likes to have some sunlight, so she never works at night with just artificial lights.

Palette

Kaiser does not use any painting medium and thins the paint with mineral spirits only in the first stage of the painting process. She uses oil paints by Sennelier, Winsor & Newton, Liquitex, Martin/F. Weber, and Grumbacher.

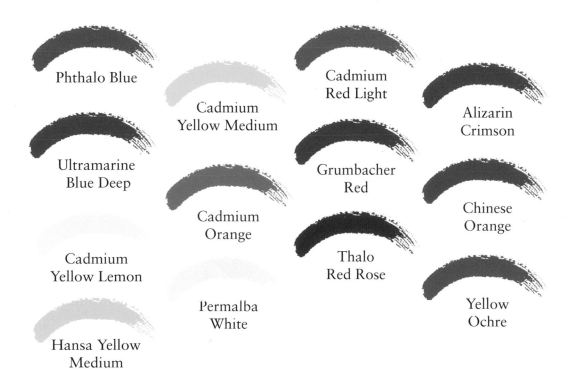

Phthalo Blue

Ultramarine
Blue Deep

Cadmium
Yellow Lemon

Hansa Yellow
Medium

Cadmium
Yellow Medium

Cadmium
Orange

Permalba
White

Cadmium
Red Light

Grumbacher
Red

Thalo
Red Rose

Alizarin
Crimson

Chinese
Orange

Yellow
Ochre

Surface

Fredrix Antwerp linen canvas stapled to wooden stretcher bars, sized from 24" x 30" (61 cm x 76.2 cm) up to 48" x 56" (121.9 cm x 142.2 cm)

Materials

Isabey bristle brushes (filberts), sizes #1 to #12

Painting
Study in White

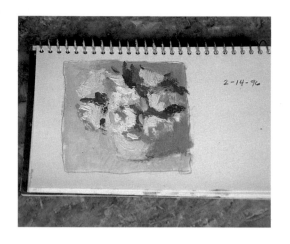

1 Once Kaiser has arranged the peonies in a vase and placed them near a floodlight, she makes a quick sketch with oil paints in her 5 ¹/₂" x 8 ¹/₂" (14 cm x 21 cm) Strathmore sketch book. She uses the sketch to plan how to paint a range of tinted white shapes. The sketch tells her to use less purple and more pink in the blossoms and to bring the values to a higher key.

2 On a 24" x 24" (61 cm x 61 cm) stretched canvas primed with white acrylic gesso, Kaiser sketches the basic outline of the peony blossoms and shadow pattern in charcoal. She refines the drawing by rubbing out and redrawing the lines until she is satisfied with the way the image fills the space and indicates the best placement of the individual forms.

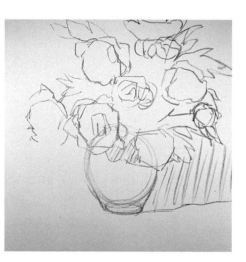

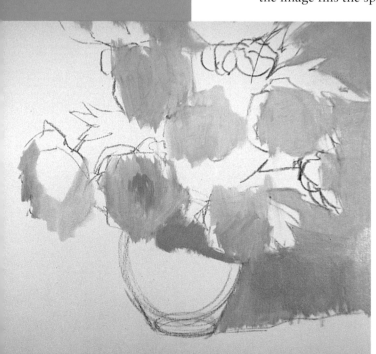

3 The artist now begins the process of establishing color harmonies and value patterns. She blocks in the middle-range values with big brush strokes and spends a lot of time looking at the flowers to determine the appropriate mixtures of colors and the correct values. She thins the paint with a small amount of mineral spirits so she can build towards thicker mixtures of the lighter values.

4 Kaiser paints the individual leaves and petals using thicker mixtures of paint and slightly smaller brushes. She doesn't premix the color, feeling it is more effective to judge what is needed for each stroke. She gradually moves to colors that are either lighter or darker than those already on the canvas.

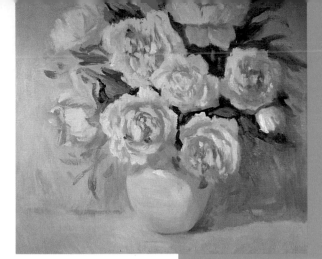

Completing the Painting

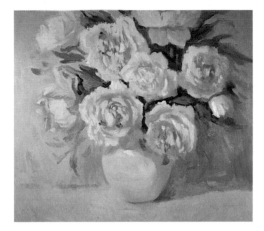

5 Kaiser refines certain areas of the picture with more contrasting values and sharper definitions of the flower petals. She decides which flowers will be focal points. As she explains, "It's important not to noodle the entire painting with details. The picture will be more appealing to viewers if some parts are left unstated."

Painting Alternatives

1 Kaiser creates another still life, this time using perishable fruit. Her procedures are exactly the same as when she works with the floral composition. She begins by blocking in the large shapes with wide bristle brushes and then focuses on progressively smaller facets of the subject.

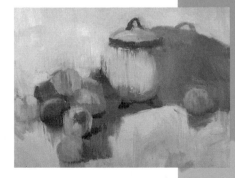

2 The greatest amount of detail is painted at the center of interest: the teapot and the nearby fruit. Kaiser balances those hard edges with soft or "lost" edges, making the objects and background seemingly blend together.

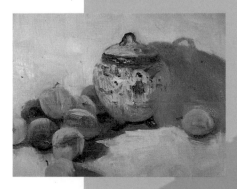

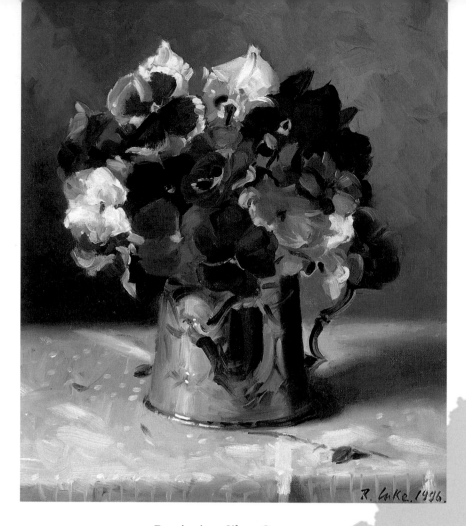

Pansies in a Silver Creamer

Oil, 15 $^1/_2$" x 12 $^1/_2$"
(39 cm x 32 cm)
Courtesy of the John Pence Gallery, San Francisco, California

Randall Lake, who has an undergraduate degree in English from the University of Colorado, studied art in the 1960s at the Académie Julian, the École des Beaux Arts, and Atelier 17 in France. He returned to the United States in 1973 to study at the University of Utah with Alvin Gittins, where he earned a Master of Fine Arts degree. Randall Lake has an established professional career painting commissioned portraits and exhibiting his still lifes, landscapes, and figure paintings with commercial galleries throughout the country.

Interpreting What You See

Utah artist Randall Lake believes in painting from life, and he will place his easel as close to a subject as possible to observe every color, texture, and value. Yet despite his devotion to painting realistically, Lake freely adds and subtracts elements, adjusts values and colors, or simply invents some portion of the picture. "The important question is: Does it work as a painting, not does it look exactly like the real thing," he explains.

The demonstration in this chapter is a clear example of what he means. A glance at the photograph of the bouquet of pansies and then at Lake's finished painting might suggest that he slavishly recorded what he saw. Yet on closer inspection, one notices differences, such as the orange and yellow pansies in the painting that don't appear in the bouquet. Lake's ability to create believable images comes from years of training and a commitment to the tradition of oil painting. But anyone can understand that a painting has its own reality that is shaped by the artist's experiences and intentions.

37

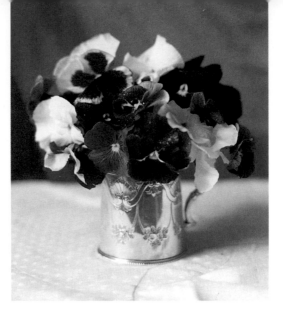

A photograph of the artist's subject.

Getting Started

In discussing some of the supplies and procedures that he uses, Lake first points out that he likes to place his subject by a north-facing window so it will be illuminated by a warm, diffused light. His studio in Salt Lake City offers six large north-facing windows, which he blocks along the lower portions so the light on his subject will be angled from above.

He stretches Utrecht raw linen canvas and sizes the surface with rabbit-skin glue. After a light sanding, he then applies one or two coats of Utrecht oil-based primer toned with burnt umber oil paint to establish a warm, beige tone.

The photograph shows what Lake is actually looking at as he paints his picture. You can refer back to it to see how he changes spatial relationships, colors, and values as the painting progresses. Lake says, "The point is to skillfully use what I see in order to construct a believable and engaging picture."

Palette

Lake prepares his white paint by mixing one part zinc white, one part lead white, a small amount of raw sienna, and quite a few drops of cold-pressed linseed oil. He never uses a pure white.

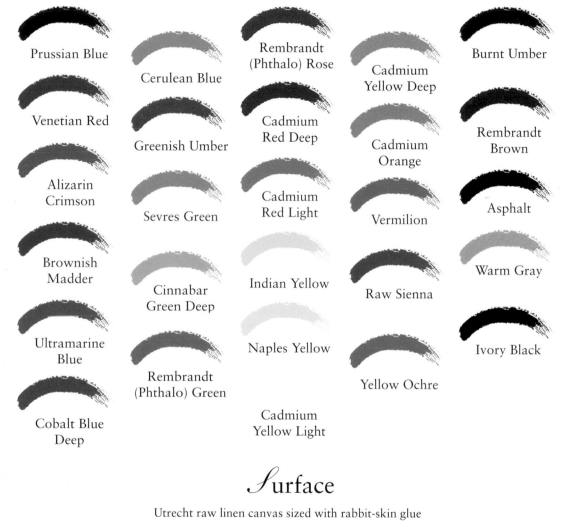

Prussian Blue

Cerulean Blue

Rembrandt (Phthalo) Rose

Cadmium Yellow Deep

Burnt Umber

Venetian Red

Greenish Umber

Cadmium Red Deep

Cadmium Orange

Rembrandt Brown

Alizarin Crimson

Sevres Green

Cadmium Red Light

Vermilion

Asphalt

Brownish Madder

Cinnabar Green Deep

Indian Yellow

Raw Sienna

Warm Gray

Ultramarine Blue

Rembrandt (Phthalo) Green

Naples Yellow

Yellow Ochre

Ivory Black

Cobalt Blue Deep

Cadmium Yellow Light

Surface

Utrecht raw linen canvas sized with rabbit-skin glue

Materials

Cornelissen filbert and round bristle brushes
Grumbacher professional flat bristle brushes
Winsor & Newton Universal synthetic brushes
Grumbacher 1" Aquarelle (to apply a thin glaze of color late in the painting process)

Winsor & Newton red sable brush #6 (to sign his paintings)
Winsor & Newton Liquin, an alkyd-based medium
Damar varnish (added to the paint to speed up drying time)

When painting a hired model or a portrait client, Lake tries to develop the entire painting all at once rather than complete the head or figure before resolving the background. For still-life painting of perishable flowers or fruits, however, he may have to paint the background and subject separately for the sake of speed.

At various stages of the painting process, Lake will place his palette table six feet back from the easel to see both the subject and the canvas from a distance. He considers this a vital step in fine-tuning color, value, and proportions. It also helps him avoid overmodeling the forms. Lake says that he instituted this practice after reading books on John Singer Sargent's methods of painting portraits.

*P*ainting
Pansies in a Silver Creamer

1 Using a mixture of raw sienna, burnt umber, and some Liquin alkyd medium, Lake starts by drawing vertical lines to mark the center and outside edges of the bouquet and silver creamer. He uses the same mixture to draw the outlines of the pansies and creamer.

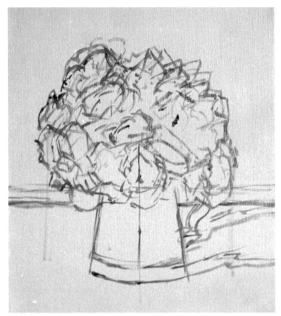

2 Lake decides to lower the entire arrangement on the canvas, so he redraws the flowers and creamer with a dark green that will dominate the first sketch.

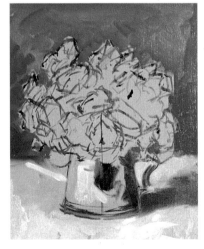

3 He now blocks in the background with a cool, bluish-purple mixture and the tablecloth with a grayish-white paint. Lake wants to silhouette the floral arrangement so he can better judge the spatial relationships.

4 Mixing enough Liquin to keep the paint thin, the artist now blocks in the petals of the pansies. He then smears the paint with his finger so the edges between highlights and shadows become soft and gradual.

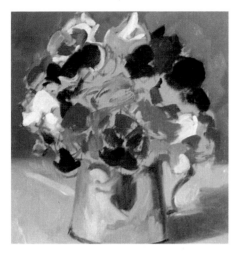

5 Lake paints refinements in the flowers. At this point (and several other times during the painting process), he sprays the painting with Grumbacher retouch damar varnish, which speeds up the drying time and makes the painting surface tacky enough to accept additional strokes of paint. He also creates some yellow and orange flowers to enliven a dead area in the middle of the bouquet.

6 Lake is not satisfied with the shapes and spatial relationships, so he invents a front edge to the table and a diagonal fold.

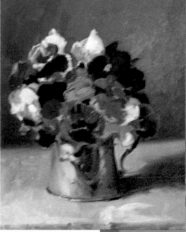

Completing the Painting

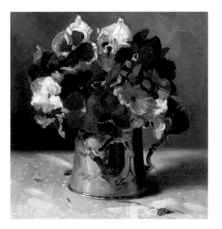

7 For finishing touches, Lake adds a diagonal light from the left to break up the background and make it less monotonous. He punches in some variant color, including blue gray, sevres green, and raw sienna, to make the background vibrate. He adds little dots of white to make the cloth look like damask and applies the brightest highlights to the silver creamer.

Still-Life Gallery

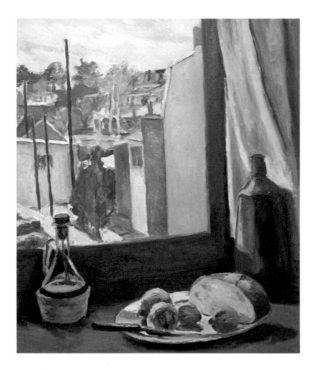

Joseph C. Skrapits
Winter Still Life (Onions on a Windowsill)
24" x 20" (61 cm x 50.8 cm)

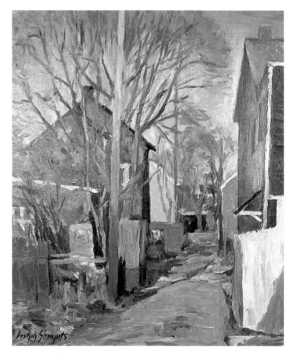

Joseph C. Skrapits
Emmett Street, Early Spring
22" x 18" (55.9 cm x 45.7 cm)

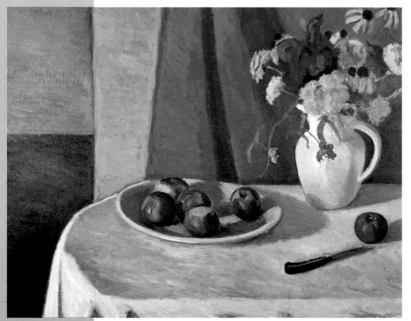

Joseph C. Skrapits
Still Life with Summer Flowers
20" x 26" (50.8 cm x 66 cm)

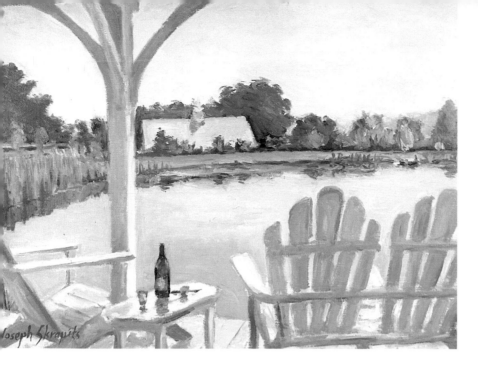

Joseph C. Skrapits
The Pond, Summer Morning
18" x 24" (45.7 cm x 61 cm)

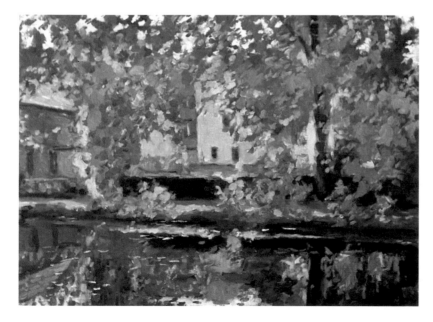

Joseph C. Skrapits
Autumn Light Along the Canal
20" x 27" (50.8 cm x 68.6 cm)

William Michael Yenkevich
Memories of a Goddess
33" x 16" (83.8 cm x 40.6 cm)

43

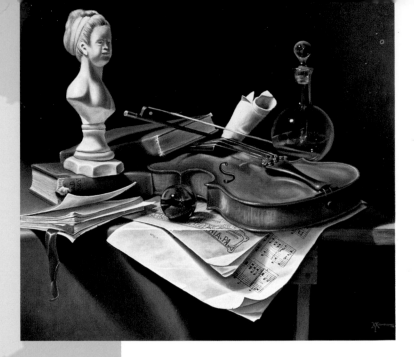

William Michael Yenkevich
Literature & Music
20" x 24" (50.8 cm x 61 cm)

William Michael Yenkevich
Fruit for the Senses
20" x 16" (50.8 cm x 40.6 cm)

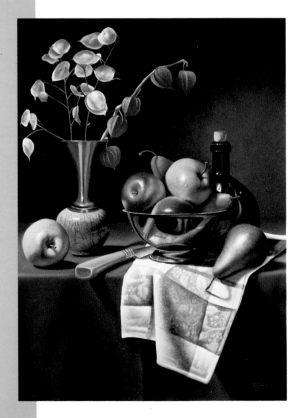

William Michael Yenkevich
Still Life Avec Pommes
24" x 20" (61 cm x 50.8 cm)

William Michael Yenkevich
Elegant Delights
20" x 24" (50.8 cm x 61 cm)

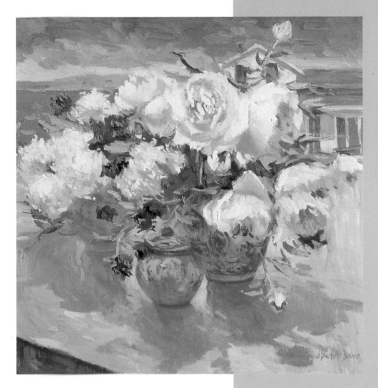

Sharon Burkett Kaiser
Sunlit Peonies and Bachelor Buttons
30" x 30" (76.2 cm x 76.2 cm)

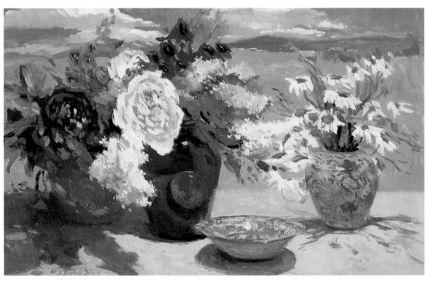

Sharon Burkett Kaiser
Flowers on the Porch
24" x 36" (61 cm x 91.4 cm)

Sharon Burkett Kaiser
California Fishing Boats
16" x 20" (40.6 cm x 50.8 cm)

Sharon Burkett Kaiser
Red Peonies and Snowballs
30" x 40" (76.2 cm x 101.6 cm)

Sharon Burkett Kaiser
The Sunny Side of the Street
30" x 30" (76.2 cm x 76.2 cm)

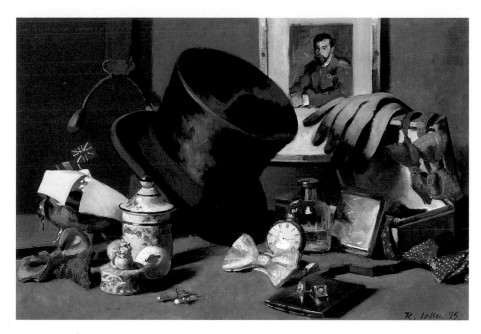

Randall Lake
Tzarist Gentleman's Accoutrements
15" x 22" (38.1 cm x 55.9 cm)

Randall Lake
Boy Pharoah—Portrait of the Artist's Son
54" x 36" (137.2 cm x 91.4 cm)

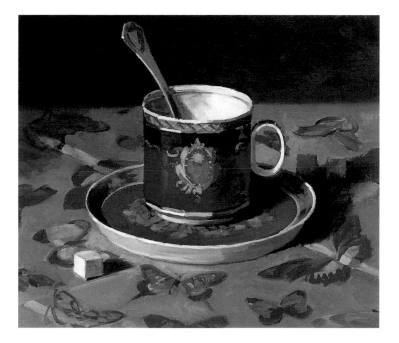

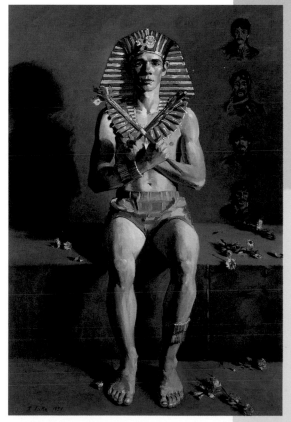

Randall Lake
Rosenthal Teacup
9" x 10" (22.9 cm x 25.4 cm)

LANDSCAPES

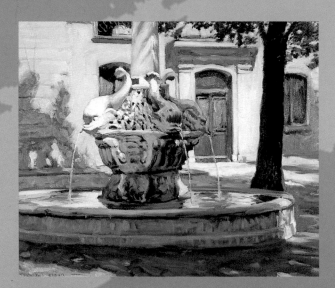
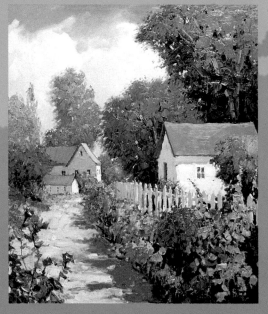

The number of landscape painters featured in this book reflects the popularity of landscapes for subject matter among oil painters. And despite the diverse approaches of the featured landscape painters, there are a few things they all have in common.

First, they are expert at editing the information that nature presents to them. They look out at a vast mountain range, an intimate garden, or a bustling street and know how to select the elements of a good painting and capture them with brush strokes of oil color. Second, each artist understands how the relationship of colors and values affects the viewer's perception of the space created on the two-dimensional surface of the canvas or board. Some rely on a balance of cool and warm colors, while others vary the play of light and dark contrasts.

Several artists work entirely on location; others take photographs or do field sketches that become the basis of larger studio pictures. Michel Tombelaine uses cut-paper collages to remind him of places he has visited, and Robert Forbes relies on a battery of photographs to help him paint photo-realistic details.

Some landscape oil paintings are about a particular moment when the sunlight and shadows strike a special pose. Others depict the overwhelming scale of nature. C. W. Mundy offers an impression of a scene he glimpsed, while Dean Larson paints details that make a scene look real. Each artist brings the viewer into a landscape of his or her own creation through their choice of colors, brush strokes, surfaces, and textures.

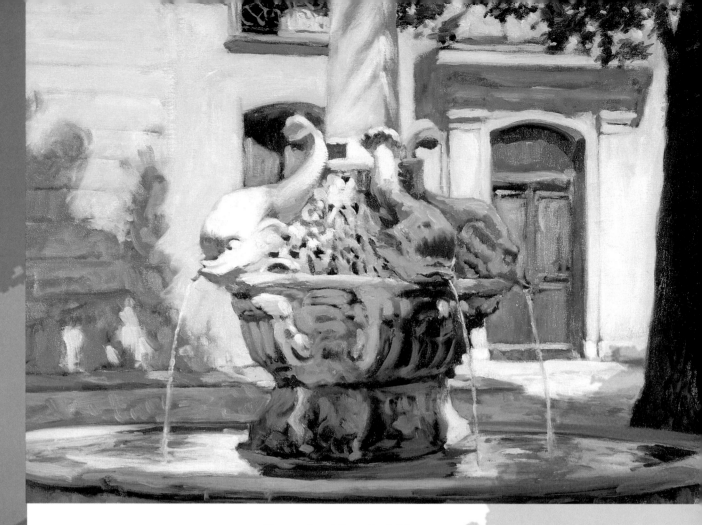

Fountain of Four Dolphins

Oil, 23" x 28"
(58.4 cm x 71.1 cm)

Born in Michigan and raised in Alaska, Dean Larson earned his B.A. from Willamette
University in Salem, Oregon, and a Master of Education from Towson State University in
Towson, Maryland. He also attended the Schuler School of Fine Arts in Baltimore,
Maryland, graduating in 1985. His teachers have included Fred Machetanz,
Will Wilson, and Ann Schuler.

Remembering a Distant Landscape

The landscapes you discover while traveling can inspire you to create oil paintings, but in many situations you won't be able to set up your supplies and paint a completed picture entirely on location. Often, you make a quick sketch or snap a photograph, hoping that you have created an accurate record of the landscape that inspired you for when you are back home in your studio.

Maryland artist Dean Larson makes a trip abroad almost every year. While hiking the hills of Tuscany or strolling the streets of Madrid, he looks for scenes that might inspire landscape paintings. When he finds them, he takes numerous slide photographs and makes quick oil or pencil sketches to help him recall the scene. Over the years, he has learned to gather the kind of visual information that will be helpful to him in remembering the distant landscape.

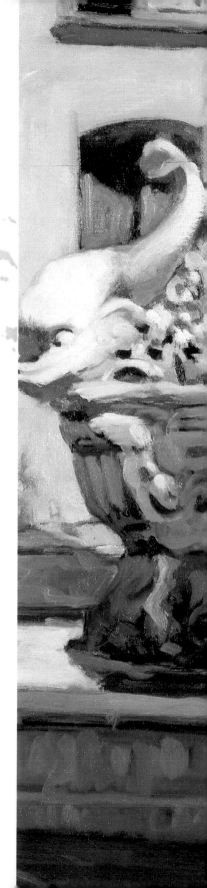

Larson carries a home-made viewer with him to evaluate potential subjects and to aid in sketching them. The viewer is simply a small piece of mat board with a rectangular window cut out of the middle. He tapes or glues pieces of red thread to the board, with two pieces crossing from one corner to another diagonally across the opening, another piece connecting the midpoints of the top and bottom sides, and a fourth piece connecting the midpoints of the left and right sides. Using the window opening, Larson isolates sections of the landscape to determine if the compositions will work for a painting; the red threads make it easier for him to sketch the landscape on a sheet of paper or canvas that has been divided by pencil lines corresponding to the lines indicated by the thread.

Painting
Fountain of Four Dolphins

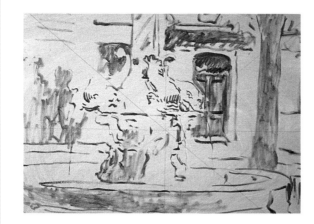

1 In order to increase the scale of the oil sketch to the size of the stretched canvas accurately, Larson draws pencil lines across the canvas that correspond to the faint grid lines on the sketch. Referring to those markings, he then draws the scene on the canvas using thin cobalt blue oil paint.

2 The artist paints the broad patterns of dark and then moves to the lighter tones. Squinting as he looks at the photograph and oil sketch, he first paints cool blacks on the ground and fountain and then warm blacks in the trees and shadows on the wall. He adds the large shapes unequally to give variety in their pattern, using thin mixtures of paint at this early stage.

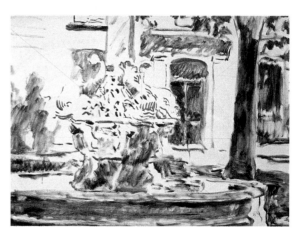

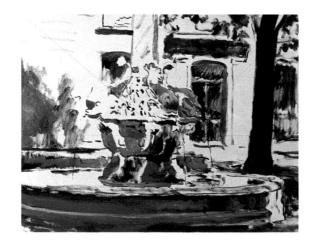

3 Carefully evaluating the relative values within the picture, Larson paints lighter mixtures of the dark tones in the fountain and the shadow on the background wall. He also fills in the foreground shadow that leads the viewer into the picture. "At this point it is important to show a distinction between the lighter tones in the shadows and the darker tones in the light areas," he comments.

4 Adding some flake white to the blacks on his palette, Larson now paints the middle-value tones on the fountain and wall of the building. He is more concerned with establishing the correct value than with the actual color at this point. Once he establishes the initial layers of paint, he can apply thin mixtures of the local colors over the black and gray values.

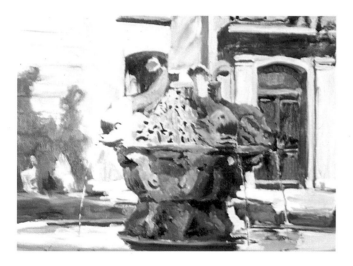

5 Now he paints the actual color of the wall using mixtures of flake white, yellow ochre, and a small amount of cadmium yellow light. He also paints some of the middle-range tones in the fountain and ground. Larson pays close attention to the transitions between the tones of the darks and lights, which he finds more important than what goes on within each tone.

Completing the Painting

6 Adding painting medium to the oils, Larson now applies more of the reflected colors to the water in the fountain, ochre to the background wall, and warmer tones to the sculpted forms in the fountain. In case certain areas need to be reworked later, he uses a brush to knock down any edges of thick paint so they won't impede repainting those spots.

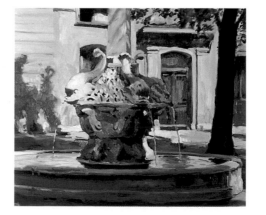

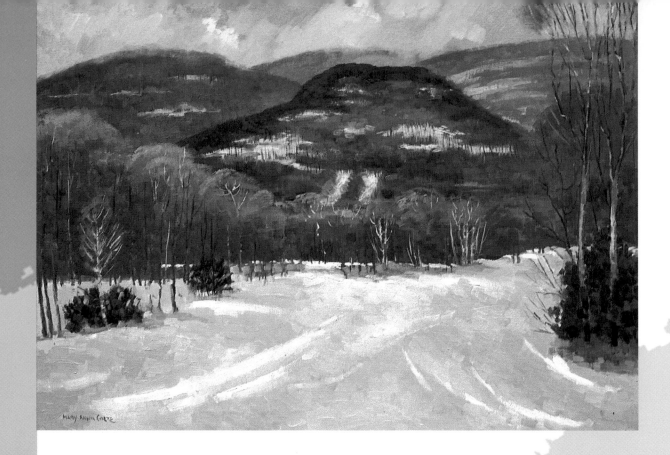

Bellayre Mountain

Oil, 24" x 30"
(61 cm x 76.2 cm)
Photo courtesy of the James Cox Gallery, Woodstock, New York

Mary Anna Goetz first studied art with her parents, Richard and Edith Goetz, and then at the
Cape School of Art in Provincetown, Massachusetts, with Henry Hensche; the Malden Bridge
School of Art in Malden Bridge, New York; and the New York Academy of Art. She is a member
of the National Association of Women Artists, the National Arts Club, the Artists Fellowship,
and the Woodstock Artists Association. Goetz teaches painting privately, and at the
Cape School of Art and the Woodstock School of Art. She is the author of
Painting Landscapes in Oil (North Light Publications, 1991).

Building on a Value Study

After years of work as a professional artist and teacher, New York artist Mary Anna Goetz has concluded that oil painters should first resolve the composition of dark, light, and middle values in a picture and then concentrate on the light source and its impact on color. To do this, she quickly blocks in a picture with three values made by the white of the canvas and slow-drying mixtures of a few earth colors. The preliminary painting becomes a plan for the picture as well as a base for other colors and finer details. In addition, the show-through effect of the underpainting helps unify the finished painting.

Goetz refers to the value painting as *grisaille*, a French term usually applied to underpaintings in shades of gray. In this process, Goetz must mix the paints with a medium that allows her to rub them off where she wants the white canvas to show through yet also to add subsequent layers of paint.

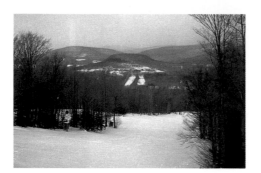

View of Bellayre Mountain from the ski lodge where Goetz sets up her easel.

The artist covers the entire canvas with a mixture of burnt sienna and burnt umber thinned with turpentine and linseed oil. She uses the same mixture to outline the distant mountains and trees.

Getting Started

Goetz almost always begins her paintings on location; when she arrives at a destination, she lays out her equipment and covers a canvas with a mixture of burnt sienna and burnt umber with ten parts turpentine (to thin the paint) and one part linseed oil (to slow its drying time). The choice of earth colors depends on how warm or cool the tone needs to be for the landscape being painted. Burnt umber gives a cool tone, while burnt sienna gives a warm tone.

Using a dark mixture, Goetz sketches the picture and then blocks in the dark masses. Next, she wipes paint off the canvas to establish the lightest values. At this point, she stands back from the canvas and evaluates the scale of the objects, the implied space within the picture, and the balance of values. She makes adjustments by applying or wiping off the earth colors. Then Goetz begins to apply color, allowing some of the earth colors to show through to create a warmth and richness. By now, she is usually ready to return to her studio and allow the paint to dry before continuing.

Palette

Although most of the colors on Goetz's palette are manufactured by Winsor & Newton, she has recently begun to use some of the Sennelier brand oils.

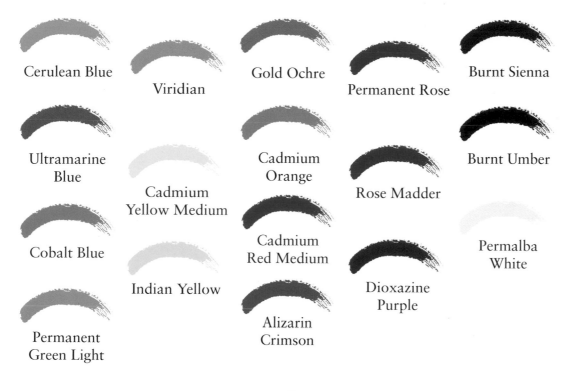

Cerulean Blue

Viridian

Gold Ochre

Permanent Rose

Burnt Sienna

Ultramarine Blue

Cadmium Yellow Medium

Cadmium Orange

Burnt Umber

Cobalt Blue

Cadmium Red Medium

Rose Madder

Permalba White

Indian Yellow

Dioxazine Purple

Permanent Green Light

Alizarin Crimson

Surface

Fredrix Antwerp canvas, single- and double-primed

Materials

Flat and round bristle brushes, sizes #1 to #8
Badger brushes (well-suited for heavier applications of paint)
Sable brushes (for details and highlights)
Grumbacher retouch varnish

Depending on the amount of texture she wants, Goetz uses either single- or double-primed Fredrix Antwerp canvas.

Painting
Bellayre Mountain

To focus her vision, evaluate compositional elements, and block in a landscape on the canvas, Goetz uses a viewer to decide what part of a scene she wants for her painting. Her current viewer is made from two pieces of Lucite plastic, but for years she used two L-shaped pieces of mat board, which she would slide back and forth until she found the right proportions and composition.

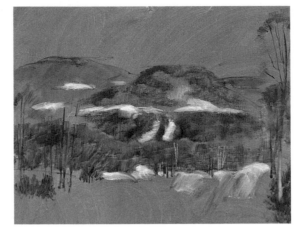

1 After blocking in the mountains and trees in two dark earth colors, Goetz uses paper towels to wipe off paint to expose the white canvas on the distant ski trails and the line of snow in the middle of the picture. She then adds more of the dark paint to mark the trees surrounding the distant ski trails.

2 Goetz now uses a large bristle brush to pull strokes of Permalba white along the ski trails in the lower half of the picture, varying the thickness of the paint as she indicates the mounds of snow surrounding the carved trails.

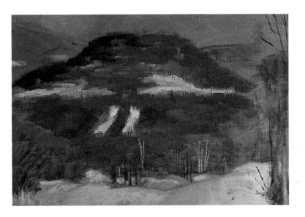

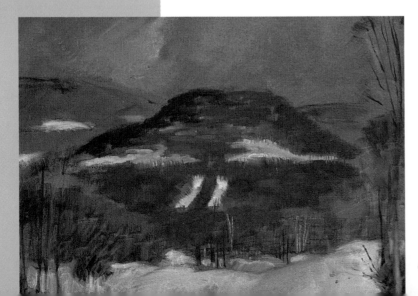

3 Using burnt umber and a small amount of ultramarine blue, the artist darkens the top of the mountain and blends the mass of trees surrounding the main ski trail.

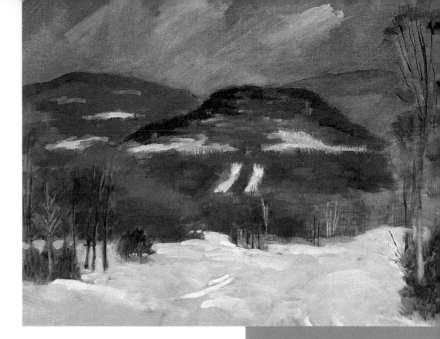

4 Mixing a small amount of cerulean blue with the Permalba white, Goetz begins to fill in the sky and the mass of snow in the foreground. Adding a little burnt sienna to the mixture, she fills in the mountains on the left and right in the distance.

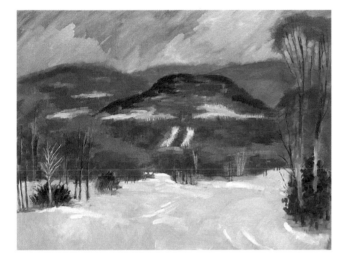

5 At this point, Goetz builds up the paint and refines the definition of the trees, mountains, and swirling masses of snow. A mixture of ultramarine blue and cadmium yellow gives her a dark green that mixes with the earth tones already on the canvas to establish the evergreens on the left and right.

Completing the Painting

6 After allowing the painting to dry, Goetz now builds up the opacity of the paint in the sky and in the thick snow. She uses a small brush to add finer details to the trees. To complete the painting, she paints the clouds and adds sparkles of sunlit snow to the distant ridge and along some of the trails with mixtures of dioxazine purple, cerulean blue, and white.

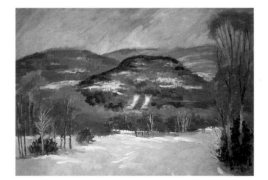

The Boatyard, Essex

Oil, 16" x 20"
(40.6 cm x 50.8 cm)

T. M. Nicholas studied at the Gloucester Academy of Art and Monserrat College of Art, both in
Massachusetts, and spent two years working with his father, artist Tom Nicholas. His paintings
have been awarded prizes in a number of national juried shows, including a silver medal from
the Rockport Art Association, the Art Students League Award from the Hudson Valley Artists
Association, and an Honor Award from the Academic Artists Association.

Interpreting Nature's Offerings

W orking directly from nature is one of the best ways to create an oil painting, because it allows you to study every aspect of your subject. Sketches and photographs are never as satisfying as the real thing when it comes to evaluating colors, shapes, and shadow patterns. But being completely faithful to nature will not necessarily give you a successful picture. Nature doesn't organize itself into the best composition; only you can select the most effective balance of elements.

T. M. Nicholas believes that an artist's ultimate goal should be to offer a personal interpretation of what he or she sees in nature. He comments, "I think the greatest art offers the artist's unique view of nature. The picture becomes a living, breathing entity because it embodies the artist's soul."

Nicholas begins a painting outdoors to gain a better understanding of his subject.

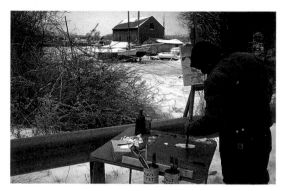

For outdoor painting, Nicholas uses a portable easel and a card table to display his palette of oil colors.

Getting Started

Nicholas combines active outdoor painting with more contemplative studio work. He begins a painting outdoors with his canvas held by a portable easel and his extensive palette of oil colors laid out on a folding card table. Working as quickly as he can, Nicholas spends four to five hours painting while the light is right and his fingers remain nimble, paying particular attention to any details that might be difficult to remember back in the studio.

After recording as much as he can on location, Nicholas returns to his studio in Essex, Massachusetts. There he can evaluate the picture and determine what additional work he needs to do. "I find that even after years of experience painting outdoors, I still need to simplify things in the studio," he explains. "Viewing the painting in that controlled environment helps me see what's really important and not become confused by the distractions outdoors."

Palette

Even when painting an overcast winter scene, Nicholas lays out a full range of colors on his card-table palette.

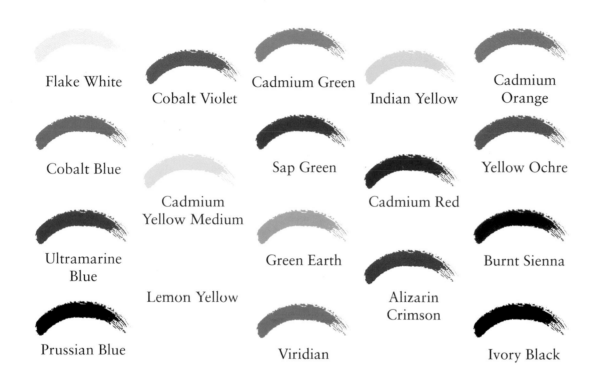

Flake White

Cobalt Violet

Cadmium Green

Indian Yellow

Cadmium Orange

Cobalt Blue

Sap Green

Yellow Ochre

Cadmium Yellow Medium

Cadmium Red

Ultramarine Blue

Green Earth

Burnt Sienna

Lemon Yellow

Alizarin Crimson

Prussian Blue

Viridian

Ivory Black

Surface

Fredrix's Rix double-primed linen

Materials

Wide, flat bristle brushes in sizes #6 to #10
Small, round bristle brushes in sizes #4 to #6
Turpentine
Portable easel

Nicholas mixes a little turpentine with his paint during the initial stages of painting. As the picture develops, he occasionally adds a medium made from a combination of stand oil, damar varnish, and turpentine to his paints. He has a container of paint thinner available for cleaning his brushes, but he makes sure to wipe that off the brushes with tissues before picking up any more oil paint.

Painting
The Boatyard, Essex

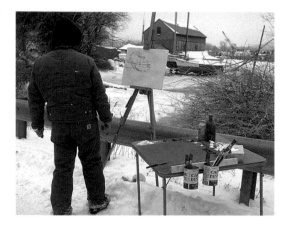

1 After setting up his portable easel and card-table palette (with one coffee can holding an assortment of flat and round bristle brushes and the other can holding paint thinner), Nicholas sketches in the basic composition with soft charcoal on a 16" x 20" (40.6 cm x 50.8 cm) Fredrix double-primed linen canvas.

2 Working with thin mixtures of color, the artist blocks in the major shapes of the buildings and distant hills. As the painting progresses, he will work with thicker paint and smaller brushes, concentrating on smaller segments of the landscape.

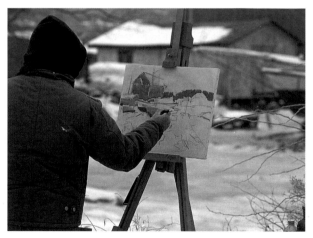

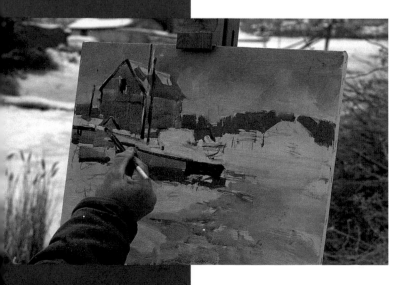

3 The weather worsens while Nicholas paints, and the gray mist threatens to block his view of the distant forms. He decides to concentrate on recording information about the boats, shoreline, and distant landscape before they disappear from view. He also takes photographs of the scene to jog his memory back in the studio.

CREATIVE OIL PAINTING

4 Now he refines the drawing of the boats, adding as many details as he can while the weather continues to work against him. He uses a grayish blue to fill in the sky and stream, then, without cleaning his brush, he picks up some of the flake white from his palette to paint the snow in the foreground and middle ground.

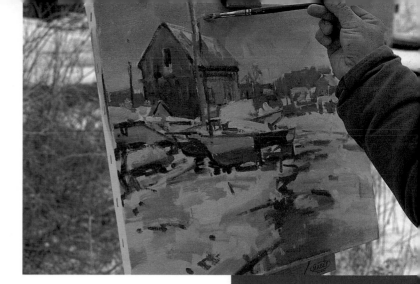

5 Once in his studio, Nicholas makes a number of changes to the appearance of the stream, in particular, using less contrast, so the stream doesn't overpower the picture. Next, he lightens the middle ground and strengthens the silhouette pattern of the dark shack and boats against the white snow.

Completing the Painting

6 Nicholas adds final details and makes subtle color adjustments to complete the painting. He leaves the canvas sitting in his studio where he can see it for a few weeks before he pronounces it finished. It often takes him some time after the experience of making the picture to know whether or not it is successful.

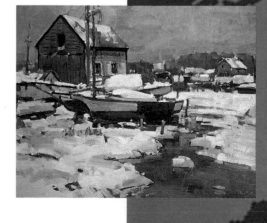

The Sanibel River

Oil, 16" x 20"
(40.6 cm x 50.8 cm)
Private collection

A graduate of Ball State University in Muncie, Indiana, C. W. Mundy continued his studies
at California State University in Long Beach. He is a member of the Indiana Artists Club,
and is a signature member of the Oil Painters of America.

Emphasizing Soft and Hard Passages

———————

When Indiana artist C. W. Mundy studied the work of great Impressionist painters like Claude Monet and William Merritt Chase, he was amazed at how effective they were in recording the appearance of a landscape at one particular moment in time using loose, gestural brush strokes of oil paint. When he stood close to the canvas, he discovered that one dab of paint defined the hard edge of a building, while another created a soft edge between overlapping folds of drapery. When he stepped back from the canvas, every one of those seemingly random strokes came together to define the place and time.

From these observations, Mundy developed his own Impressionist style of oil painting that involves the deliberate "molestation" of brush strokes so they become soft and "lost" in contrast with those that are hard and "found." Mundy does not adhere to a formula when painting, but he does follow certain procedures so that his pictures are structurally sound as well as a reflection of his mood and observations.

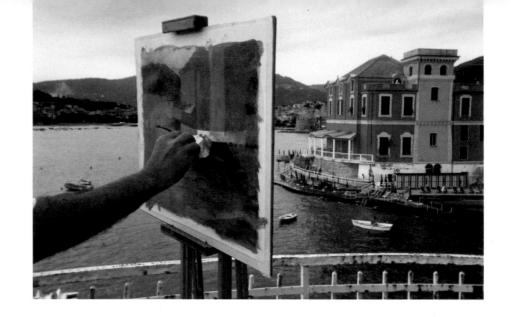

To soften the forms in the painting, Mundy wipes the wet paint using tissues.

Getting Started

"People have a tendency to overwork their oil paintings, and their pictures turn out looking mechanical and repetitive," Mundy says. "I try to first establish the broad pattern of forms with wet, fluid applications of paint, and then I wipe tissues back and forth across the canvas in different directions so I get a unified composition of lost and found edges. Only then do I paint the details that identify all of the objects for the viewer." This tissue technique, which requires more than a dozen sheets of tissues, softens the edges of some of the forms and lends an Impressionistic look to the picture.

After years of experimentation, Mundy has discovered that the process works best if he works directly on location with a specific palette of colors. He formulates the composition in his mind's eye at this early stage by determining what the dominant color will be and where he will place the lightest lights and the darkest darks. He mixes up "pots" (several tablespoons full) of each of the major greens and blues he will need, judging the hue and value by holding up a palette knife covered with that color against the light so he can judge it against the real landscape.

Palette

Mundy uses a board covered with white Formica as his palette. Its smooth surface is easy to clean and the stark white color helps him judge the color and degree of transparency of the oil paints he mixes on it.

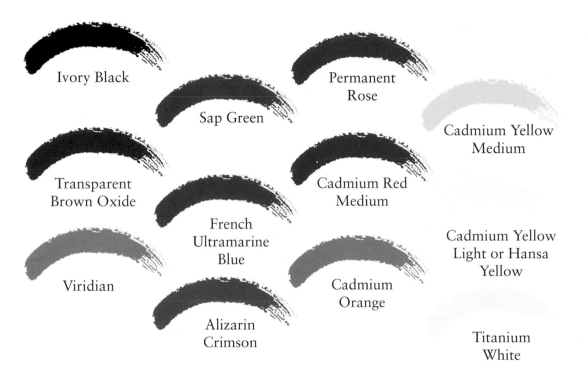

Ivory Black

Sap Green

Permanent
Rose

Cadmium Yellow
Medium

Transparent
Brown Oxide

Cadmium Red
Medium

French
Ultramarine
Blue

Viridian

Cadmium Yellow
Light or Hansa
Yellow

Cadmium
Orange

Alizarin
Crimson

Titanium
White

Surface

Oil-primed linen

Materials

Rectangular cardboard viewer
Flat bristle brushes in sizes #2, #4, #6, #8, #10, and #12

Painting
The Sanibel River

1 Mundy tapes an 18 ½" x 22 ½" (47 cm x 57 cm) piece of oil-primed Belgian linen to a sheet of Masonite and applies a thin wash of burnt sienna using a #12 bristle brush. He wipes a tissue across the canvas to even out the paint and remove any obvious brush marks. While the paint is still wet, Mundy marks the placement of key elements and then paints thin mixtures of a dark and middle-value green with vertical strokes of a bristle brush.

2 Mundy squints at the subject during these early stages because he wants to see only the big shapes, not the details. He paints vertical strokes of blue in the sky and water. Mundy includes some of each color in the mixtures he prepares so there is harmony between the colors; he mixed a little bit of green, red, and yellow into this light blue sky color.

3 The artist applies more green to the trees and their reflection, and he darkens the water by adding a purple mixture to the light blue on his palette. He needs to have thick, fluid paint on the canvas before wiping the edges. Mundy allows the underpainting to show between brush strokes of green and blue to unify (but not overwhelm) the painting.

4 After the solid shapes are filled in with the correct value, Mundy uses tissues to wipe the oil paint in different directions, creating soft edges and blending the colors into the burnt sienna background. He continues to squint when he looks at his subject to ensure simplified value control and to help him see the temperature of color in the shadowed areas.

5 Looking through the viewer again at the real landscape, Mundy reconsiders where he will reinforce the dark and light colors with thick mixtures of paint. He uses smaller brushes and concentrates on details in the foreground. If a mark seems too harsh, he strokes part of it with a clean tissue.

Completing the Painting

6 Mundy notes that many great painters (notably Whistler and Sargent) used this technique of wiping out and repainting until they achieved a picture that looked fresh and was an accurate depiction of the subject. He feels a need to be faithful to his subject, with the goal of expressing how he feels about it. "This is the essence in and the merit of the history of art," he says.

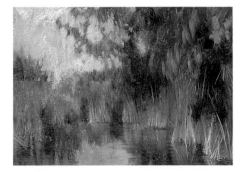

Water Fall of Lights

Oil, 29" x 43"
(73.7 cm x 109.2 cm)

A graduate of Southern Illinois University in Carbondale, Robert Forbes began creating Photo-
Realistic oil paintings in 1969 and became a full-time professional artist in the early 1980s.

Painting Photo-Realistic Images

We are conditioned to believe that an image with the slick look of a photograph must contain an unaltered view of reality. But there are many ways to select, compose, and adjust an image to create a believable picture of something that may have existed only briefly. A skilled oil painter can convince viewers that a scene exists exactly as depicted, when in fact the image is a personal interpretation of the scene.

Missouri artist Robert Forbes creates convincing pictures of urban scenes that are as fleeting as a Monet water lily or a Van Gogh cornfield. They exist only on his canvas, because he captured them at one moment in time and exaggerated the visual qualities he found most appealing. Just as Monet manipulated his brush work to blur the distinction between flower petals and rippling water and Van Gogh used crusts of paint to resemble cornstalks, Forbes controls how he applies oil paint to the canvas so that it conveys his feelings about a chosen subject.

Getting Started

In his studio, Forbes projects the slide photographs he has taken of a theater marquee onto the smooth surface of a canvas that has been stretched over foam board, attached to standard canvas stretcher bars, and coated with about a dozen layers of Fredrix acrylic gesso mixed with acrylic gloss medium. "It's critically important for the painting surface to have a glass-like, smooth, hard surface," he explains. "After each coat of the gesso-medium mixture has dried, I sand it smooth. Some coats are sanded with wet sandpaper that doesn't clog or produce dust."

Forbes then draws the projected image lightly in pencil and sprays a thin layer of the gesso-medium mixture over the graphite lines to keep them from smudging during the painting process. A reference photograph of the theater marquee lies in the middle of the unpainted canvas.

Palette

Forbes uses a limited number of strong pigments that blend well together as he softens the edges between reflected lights. He includes two phthalo colors on the palette, which, when blended with titanium white, will easily take on the appearance of fluorescent lights.

Phthalo Blue

Burnt Sienna

Dioxazine Purple

Black

Cadmium Orange

Cadmium Yellow Medium

Titanium White

Phthalo Green

Surface

Stretched canvas coated with Fredrix acrylic gesso mixed with acrylic gloss medium

Materials

Pencil
Sandpaper
Gesso-medium mixture

77

Painting
Water Fall of Lights

1 Forbes first projects a photograph of a theater marquee in Mattoon, Illinois, onto a prepared 29" x 43" (73.7 cm x 109.2 cm) canvas. He completes one section, starting with the patch of sky in the upper right-hand corner and then moving to the part of the marquee illuminated by daylight. His reference photograph is lying in the middle of the unpainted canvas.

2 To achieve a photographic look, the artist spends time blending colors by repeatedly stroking the surface of the wet paint. He finds that long-haired synthetic brushes work particularly well for this kind of blending. Here he mixes colors to create a halo effect around the edges of the neon and incandescent light bulbs.

3 Forbes remembers that the front of the marquee is illuminated by a cool natural light and needs to be painted with bright reds, blues, and yellows. He paints the incandescent light bulbs after he completes the metallic surfaces around them.

4 The detail makes it easier to see how Forbes is painting the warm glow of light on the underside of the marquee. You can also see where he uses a liner brush held against a straight edge to paint the thin lines of neon lights running diagonally across the canvas.

5 Forbes exaggerates the variety of glowing colors within the incandescent bulbs on the underside of the marquee and on the reflective surfaces around them. "Some people think my paintings

are just copies of photographs, but in fact they show a world of lights and reflections," he says. "I create a world made out of paint. The Photo-Realistic images are big enough for me to be able to get inside the individual parts and make them more interesting. A single light bulb is not just rendered as a blob of white paint but rather as a complicated pattern of reflective surfaces."

6 The artist emphasizes the contrast between the sharp pattern of sunlight and shadow on the front edge of the marquee and the subtle glow of reflected lights below. Throughout the painting process, he keeps his paints rather thick but fluid. He wants a solid coverage of the canvas without any visible brush strokes.

Completing the Painting

7 Now that the initial applications of oils have dried, Forbes goes back to paint some of the neon tubing and linear details. He avoids repainting any sections of the picture because that might destroy the photographic illusion created by the wet-in-wet blending of color.

Sunshine and Color

Oil, 40" x 30"
(101.6 cm x 76.2 cm)
Courtesy of the May Galleries, Scottsdale, Arizona

Although Kent R. Wallis showed a talent for art as a child, he earned a B.A. and a master's degree in business administration from Utah State University. After working as a business executive for a number of years, he started a retail art supply business in his hometown of Logan, Utah. He later sold his business and now focuses entirely on his artwork. Wallis has won a number of awards in juried art shows and is a member of both the Society of Plein Air Artists of America and the Northern California Society of Plein Air Painters.

Using High-Key Color and Thick Paint

The color, texture, and tone of oil paint tells the viewer as much about the artist's attitude as does the subject matter itself. Paint that is built up in polished layers is appropriate for rendering fine details, precise edges, and subtle gradations of tone; thick paint lends itself to dabs of swirling colors that give the general impression of a scene. Likewise, dark, smoky colors create a moody atmosphere, and bright, high-key colors convey a feeling of energy and excitement.

Utah artist Kent Wallis employs thick strokes of bright oil paint to suggest water cascading over a dam and flowers spilling onto a country lane. He works quickly with large bristle brushes and a flexible palette knife to build up wet strokes of colors. Wallis chooses high-key yellows, oranges, reds, and pinks to give the impression of objects, which he sets off against dark shadows made from lavenders, blues, and mauves. There is richness and depth to every section of the canvas.

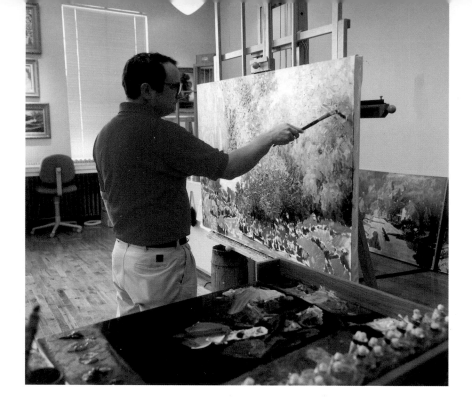

Wallis at work in his studio.

Getting Started

Once he shoots his subject, Wallis has the photographs recorded on a photo CD so he can view them on a large-screen television in his studio. He does his initial painting while looking at the 36" x 48" (91.4 cm x 121.9 cm) projected image, but turns the television off after the first hour of work. At that point, he becomes more concerned about the painting as a work of art and less about its relationship to the scene that inspired it.

Wallis, who majored in business in college, is very organized and systematic in his approach to oil painting. At work in his spotless Logan, Utah, studio, he uses a large slab of black glass for a palette so he can see just how transparent or opaque his paints are before he applies them to the canvas. He also uses long-handled bristle brushes so he can stand back from the painting and see the Impressionistic patches of color blend together to establish the landscape image.

Palette

Wallis has an extensive selection of tube colors because he prefers to have colors mix on the canvas rather than on the palette. These paints are manufactured by Schmincke, Winsor & Newton, Liquitex, and King.

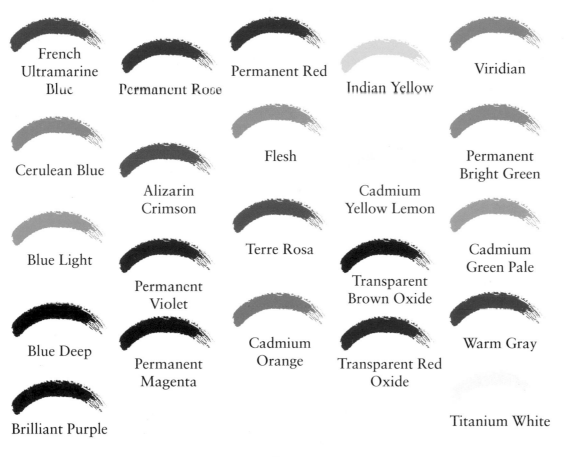

French Ultramarine Blue

Permanent Rose

Permanent Red

Indian Yellow

Viridian

Cerulean Blue

Flesh

Permanent Bright Green

Alizarin Crimson

Cadmium Yellow Lemon

Blue Light

Terre Rosa

Cadmium Green Pale

Permanent Violet

Transparent Brown Oxide

Blue Deep

Cadmium Orange

Warm Gray

Permanent Magenta

Transparent Red Oxide

Brilliant Purple

Titanium White

Surface

White canvas

Materials

Palette knife
Large bristle brush

Painting
Sunshine and Color

1 On a frame stretched with Fredrix single-primed linen canvas, Wallis draws the outline of the various elements of the landscape using French ultramarine blue oil paint thinned with copal painting medium. He refers to photographs of the subject on a large-screen television in his studio.

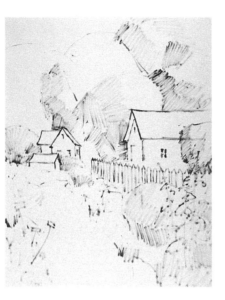

2 Starting at the top of the canvas, the artist quickly blocks in the background sky and trees, keeping the values light and reducing the contrast between light and dark so the objects will appear to be in the distant space.

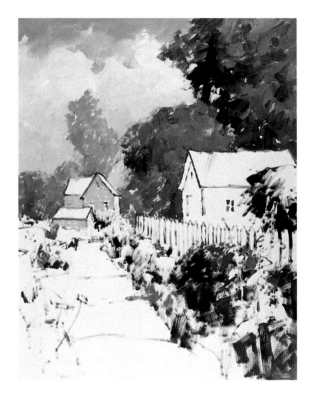

3 Moving into the middle ground and foreground, Wallis continues to use a large bristle brush to block in the basic shapes of the bushes, lane, fence, and house.

4 While the first layers of paint are still wet, Wallis goes back to the top of the canvas to scrape paint away from some areas and build it up in others. He emphasizes the sunlight hitting the right edges of some shapes and casting cool shadows to the left.

5 Using both a brush and a palette knife, Wallis adds colorful flowers to the foreground bushes. As he applies thick paint, he makes a point of moving his hand in different directions so there will be a variety of marks on the canvas.

Completing the Painting

6 Wallis adds small details, such as windows, doors, and blossoms, to finish the painting.

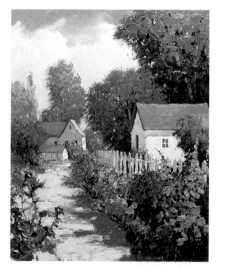

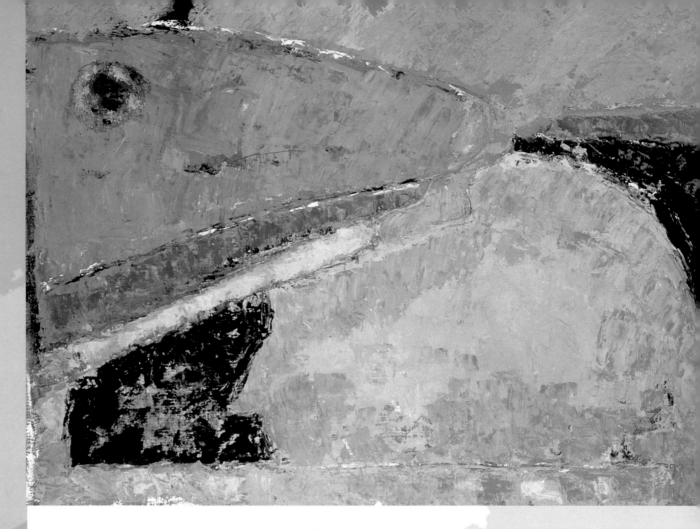

Laayoune

Oil, 42" x 56"
(106.7 cm x 142.2 cm)
Private collection

A French native, Michel Tombelaine moved to New York when he was in his twenties and began
a 30-year career as a journalist for the United Nations Press Service and various French media.
At the age of 50, he began to study painting at the National Academy of Design and the Studio
School, and he earned a Master of Fine Arts degree from Parsons School of Design.

Distilling the Essence of Form

The boundaries between abstract and representational painting are not as sharply defined as one might imagine. Realistic paintings have to maintain an abstract balance, and abstract paintings are usually inspired by the artist's experience. The differences between the two stylistic approaches are mostly a matter of emphasis.

Michel Tombelaine feels that by emphasizing the geometric shapes, surface textures, color tensions, and spatial patterns within his pictures, he is able to express his feelings about a landscape more completely than if he offered a photographically accurate representation of its appearance. By continually shaping and reshaping the forms within the canvas, he is able to express the emotions bound up in the places recorded in his sketches and memory.

Tombelaine considers drawing to be an important part of his creative process. Although not a figure painter, he regularly joins a figure-drawing session; the experience of drawing a nude model helps sharpen his powers of observation and hand-eye coordination.

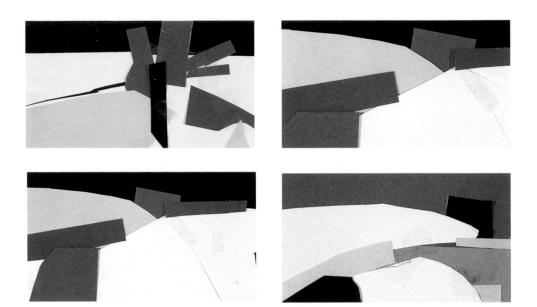

Getting Started

In addition to drawing figures and landscapes, Tombelaine makes small collages using colored paper to help him translate his notions about a place into a pattern of shapes. He doesn't use the landscape's actual colors because those would put too much emphasis on the real place and not enough on the relationship of the spaces and shapes. Tombelaine includes black paper in these collages because he finds that black establishes an extreme that he can work against as he builds a picture.

The painting in this chapter was inspired by the Western Sahara desert, where Tombelaine worked for the United Nations in 1993 and 1994, and where he made a number of pencil and charcoal sketches as the basis for oil paintings. For this work, he translates his memory of the Western Sahara into several 8" x 10" (20.3 cm x 25.4 cm) collages that are the starting point for a 42" x 50" (106.7 cm x 127 cm) oil painting on rough-surfaced jute canvas.

Palette

Tombelaine usually begins painting with just two colors on his palette: French ultramarine blue and yellow ochre. The contrast of those colors allows him to block in the basic forms of the composition. He will then add some other colors as needed.

French Ultramarine Blue

Viridian

Quinacridone Red

Hansa Yellow

Yellow Ochre

Cerulean Blue

Coral

Lemon Yellow

Ivory Black

Red Ochre

Alizarin Crimson

Cadmium Red Deep

Surface

Rough-surfaced jute canvas

Materials

Colored paper
Dorland's wax medium
Bristle brushes
Palette knife
Masonite

Tombelaine likes to tape his canvas to a large sheet of Masonite so the painting surface will be flat and inflexible while he is working on it. Once the painting is completed, he stretches the canvas across standard wooden stretcher bars.

Because he likes to scratch into the surface of his paintings or scrape off entire passages, Tombelaine often mixes Dorland's wax medium with his oil paint to make those revisions easier. The wax medium also builds up the thickness of the oil paint and allows Tombelaine to press textural materials into the impressionable paint. Although he uses bristle brushes, he does most of the paint application with a palette knife because it lends itself to rough textures and paint scumbling.

Painting
Laayoune

Tombelaine works steadily on one painting for several days, applying new layers of paint to the existing wet surface. He then puts the canvas aside for a few days and begins a new picture. Once the second painting has been blocked in, Tombelaine returns to the first canvas with a fresh view of its strengths and weaknesses and then determines what more he may want to do with it. He often has three or four paintings in various stages of development. When he feels some sense of resolution about a picture, Tombelaine puts it away for several weeks or months before deciding that it is finished. Sometimes he adjusts a picture, and sometimes he completely destroys it. More often than not, however, Tombelaine feels confident about the painting and applies his signature.

1 After taping a piece of rough-surfaced jute canvas to a sheet of Masonite, Tombelaine applies brush strokes of acrylic gesso over portions of the canvas. The acrylic gesso begins to establish a textural surface by sealing parts of the fabric.

2 Using a large bristle brush and thin mixtures of oil paint, Tombelaine blocks in the large shapes within his composition. Notice that, although the divisions of space are similar to those in the colored paper sketches, the colors and values have changed significantly.

3 Using a palette knife, Tombelaine now scrapes thick mixtures of oil paint over the rough canvas, allowing the initial washes of color to show through and create a rich textural effect. He completely covers some of the shapes visible in the previous stage.

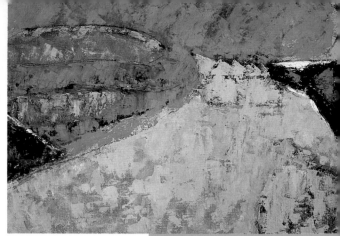

4 The Dorland's wax medium mixed into the oil paint makes it thicker and easier to scrape off the canvas. Here Tombelaine reestablishes one of the ochre shapes by scraping off the blue paint over it. The dark shape on the right side of the picture is also changed.

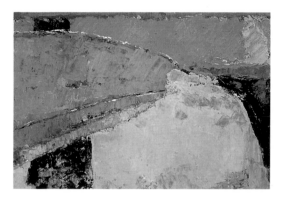

5 From this point on, Tombelaine makes fewer changes in the overall composition and concentrates on enriching the texture and color depth of the painting by scumbling additional layers of paint.

6 Tombelaine holds a piece of red colored paper against the right side of the canvas to judge how the introduction of such a color would affect the developing picture. He decides that a small dot of the red, balanced with some purple shapes along the horizontal division, will work well.

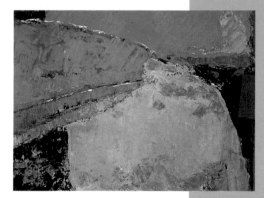

7 Tombelaine adds layers of paint to the top and bottom of the canvas and inserts the red and purple shapes. He sees the shape of a shark's head in the upper left quadrant of the painting which, although somewhat amusing, might be distracting to the viewer. He reduces the size of the shark's fin to make the animal less obvious.

Tombelaine puts the painting out of sight for a few days and works on another canvas. When he brings the canvas back into the studio, he can look at it with a fresh vision to determine if any adjustments should be made. Once he finishes the painting, he takes the canvas off the temporary Masonite support and stretches it across wooden stretcher bars.

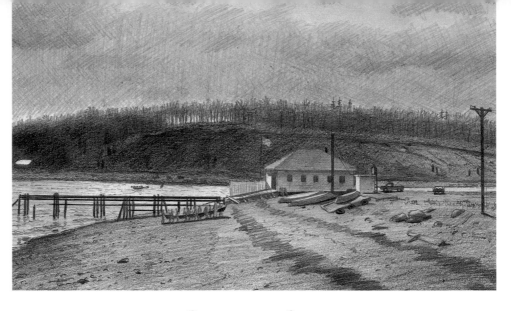

Getting Started

Every step of his outdoor painting procedure is calculated so that McGurl can record as much information as quickly as possible. Before beginning the painting process, McGurl makes a 10" x 16 ½" (25.4 cm x 42 cm) pencil sketch to determine how he will alter the composition of his oil sketch when he enlarges the image onto the 28" x 46" (71.1 cm x 116.8 cm) canvas. He doesn't think of this drawing as a finished work of art, but, rather, as a study that organizes the dark and light shapes. He then paints small panels on location and uses those as the basis of large studio paintings on canvas. He works on sheets of Masonite coated with acrylic gesso and toned with either a warm gray (for midday paintings), or burnt sienna (late afternoon scenes).

On this surface, McGurl first draws a few lines in charcoal to place the basic elements of the scene. These are redrawn with a graphite pencil so he can brush away the charcoal and prevent it from sullying the oil paint. The next step is one of the secrets of McGurl's efficient painting method. He applies a layer of sun-thickened linseed oil over the entire panel to establish an oily surface on which to paint. His brushes will glide more easily across this slick surface than they would across a dry gesso surface.

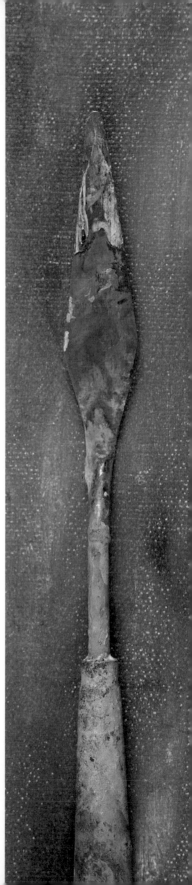

Palette

When painting outdoors, McGurl lays out a palette of alkyd paints. In his studio, McGurl uses the same colors in oil paints.

Titanium
White

Burnt Umber

Prussian Blue

Yellow Ochre

Cadmium
Yellow Light

Permanent
Green Light

Cadmium Red

Dioxazine
Purple

Burnt Sienna

Cadmium
Yellow Deep

Terre Verte

Alizarin
Crimson

Black

Cobalt Blue

Raw Sienna

Cadmium
Orange

Ultramarine
Blue

Lead White

Cadmium Green

Surface

Stretched canvas

Materials

Stiff bristle brushes

McGurl uses a couple of old, stiff bristle brushes that are ideal for painting textural patterns quickly. By stippling and scrubbing paint with these stiff brushes against the canvas or Masonite, he can suggest the leaves on a tree, tall grasses in a field, or the rough surface of a boulder.

Painting
Point Allerton

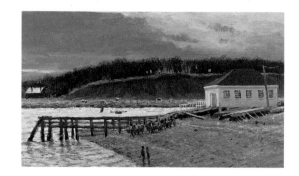

1 McGurl sets up his easel near the entrance of Boston Harbor in Hull, Massachusetts, and quickly paints this 8" x 12" (20.3 cm x 30.5 cm) picture of a group of young rowers carrying their boat from an old Coast Guard boat house. The weather was cold and windy, so he worked quickly to paint and, in the process, to commit the scene to memory.

2 Back in his studio, McGurl uses charcoal to draw the basic lines of the boat house, shoreline, and distant island on a stretched canvas. He alters the image in his oil sketch by elongating the composition and changing the direction of the shoreline. Once satisfied, he redraws the lines in pencil and rubs the charcoal off the canvas.

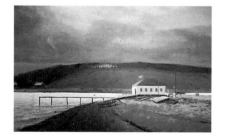

3 Using thin mixtures of a limited number of oil colors, McGurl blocks in the large shapes within the scene and adds further definition to the beach, boat house, sky, and hillside. Throughout the painting process he adjusts the line of the shore since it is a major directional force in the composition.

4 The rowers, buildings, and boats are defined even further, and McGurl makes the light along the top of the distant island more important to the composition. A variety of surface textures is built up in anticipation of the glazes and scumbles that will be added later to enhance this textural effect.

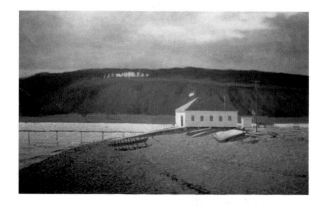

Completing the Painting

5 After studying the composition, McGurl decides that the details are distracting the view from the overall composition. To correct that, he now puts a dark glaze over the island, removes the bright highlight from the small building, paints over some of the rocks in the foreground, and turns the small white boat into red so it matches the others.

Painting Alternatives

1 Having worked for many years as a yacht captain, McGurl recognizes that the fiberglass boat in this oil sketch is not native to the island of St. Thomas, where he is painting. So when he begins making pencil drawings for the large studio painting, he adds sailboats and a fishing boat that would better fit the Caribbean setting. He also used sketches done on location to place the mountains in the background.

2 Because he spends so much time observing nature, McGurl finds it easy to change the shapes and values in his oil sketch so that his large painting would be successful. He reduces the scale of the hill behind the sailboats and casts it completely in shadow to help dramatize the sense of depth within the picture. He also changes the configuration of buildings along the shoreline, adding and subtracting people, and deepening the color of the water.

Landscape Gallery

Dean Larson
San Michele, Venice
24" x 32" (61 cm x 81.3 cm)

Dean Larson
Jardines del Alcazar, Sevilla
28" x 34" (71.1 cm x 86.4 cm)

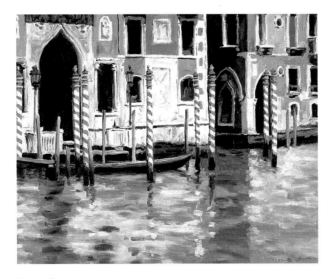

Dean Larson
Posts and Palazzos, Venice
22" x 28" (55.9 cm x 71.1 cm)

Mary Anna Goetz
Next May
30" x 36" (76.2 cm x 91.4 cm)

Mary Anna Goetz
October Afternoon
40" x 50" (101.6 cm x 127.0 cm)

Mary Anna Goetz
Willow in October
24" x 30" (61 cm x 76.2 cm)

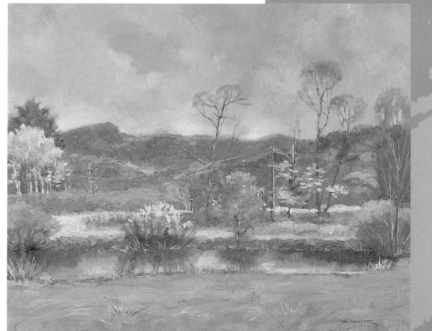

T. M. Nicholas
Spring Hillside, Vermont
18" x 30" (45.7 cm x 76.2 cm)

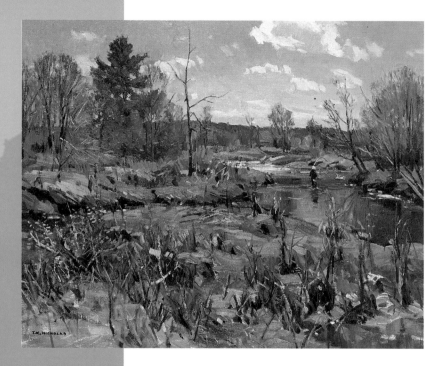

T. M. Nicholas
Along the Blackstone
24" x 30" (61 cm x 76.2 cm)

T. M. Nicholas
Warming Up, Gloucester
30" x 40" (76.2 cm x 101.6 cm)

C. W. Mundy
Cote D'Azur, Port de Cannes
16" x 20" (40.6 cm x 50.8 cm)

C. W. Mundy
Cote D'Azur, Viaduc de La Rague
16" x 20" (40.6 cm x 50.8 cm)

C. W. Mundy
Bailey Tract Canal
16" x 20" (40.6 cm x 50.8 cm)

Robert Forbes
Something Wild
54" x 31" (137.2 cm x 78.7 cm)

Robert Forbes
Have a Seat
42" x 47 1/$_2$" (106.7 cm x 120.7 cm)

Robert Forbes
Push Pull Art (Detail)
32 1/$_2$" x 48"
(82.6 cm x 121.9 cm)

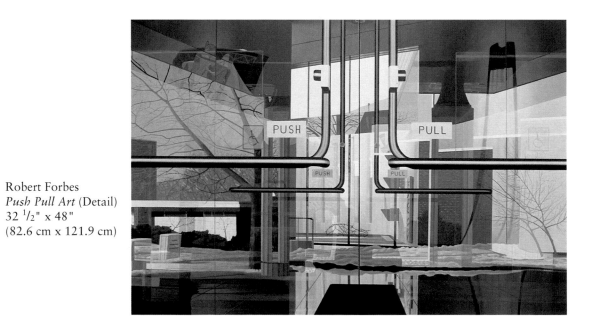

Kent Wallis
Shutters Encase
36" x 48" (91.4 cm x 121.9 cm)

Kent Wallis
Waterfall Garden
48" x 36" (121.9 cm x 91.4 cm)

Kent Wallis
Home Tucked In
24" x 36" (61 cm x 91.4 cm)

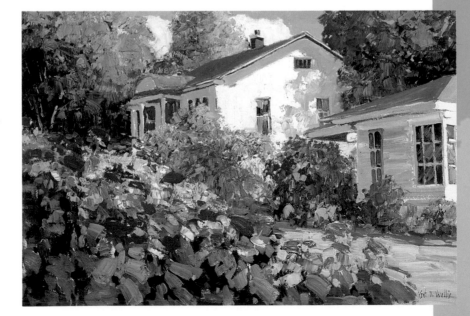

Michel Tombelaine
Central Park
28" x 44" (71.1 cm x 111.8 cm)

Michel Tombelaine
Spain
26" x 32" (66 cm x 81.3 cm)

Michel Tombelaine
Near Paris
14" x 18" (35.6 cm x 45.7 cm)

Joseph McGurl
Below the Apex
24" x 36" (61 cm x 91.4 cm)

Joseph McGurl
Prince Head
20" x 36" (50.8 cm x 91.4 cm)

Joseph McGurl
The Coastal Realm
28" x 46" (71.1 cm x 116.8 cm)

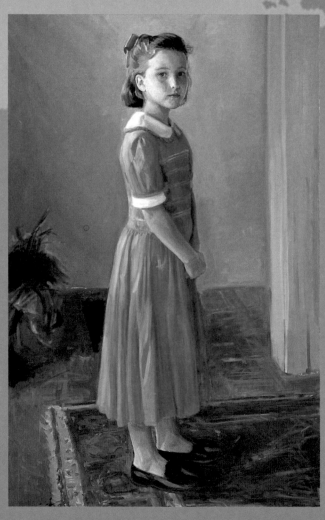

The human figure is perhaps the most difficult subject to include in an oil painting because of the skill required to render it convincingly, and because the figure almost always becomes the focal point of the composition. While viewers may never know when an artist has distorted the shape of a tree or an apple, they will immediately recognize the slightest imperfection in the rendering of a human form.

Figure painters usually spend time posing and drawing models, photographing crowds of people, and evaluating several overall plans for a picture. Elizabeth Torak does extensive preliminary drawing and painting, carefully considering each part of the figure's body as well as the objects surrounding it. This preliminary work helps the artist to present the figure more accurately in the finished oil painting.

Joanette Hoffman Egeli explains how to handle the complexities of painting a commissioned portrait and provides tips for painting flesh tones, clothing, and background. As an experienced painter, Egeli knows how to capture that all-important likeness that clients expect in a portrait.

Dan Gerhartz is interested in painting figures out in a landscape, and he frequently asks friends and family members to pose among the trees, barns, and animals near his home in Wisconsin. The challenge of dealing with wind, cold weather, and changing light is considerable, but Gerhartz feels it is important to meet that challenge in order to express his feelings about wholesome rural lifestyles and values.

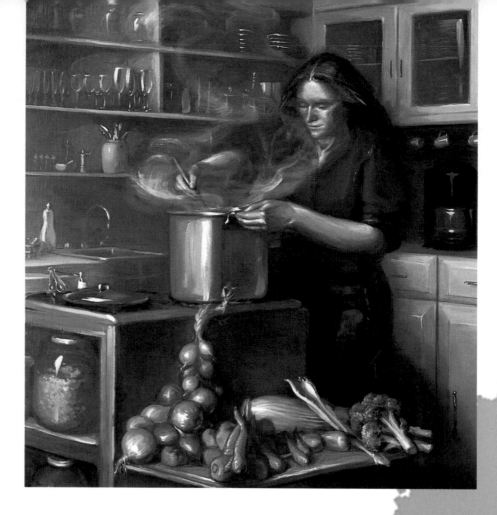

Stirring the Pot

Oil, 28" x 24"
(71.1 cm x 61 cm)
Courtesy of G. C. Lucas Gallery, Indianapolis, Indiana

While attending high school, Elizabeth Torak spent summers studying painting at the Art Students League of New York. After completing her education at the University of Chicago, she returned to the League, where she studied with Frank Mason. She is a member of the Audubon Artists, American Artists Professional League, and Oil Painters of America.

Painting Luminous Veils of Color

L ike most of the artists featured in this book, Elizabeth Torak assigns great importance to value, light, and color relationships. But there is another element that is especially important to her work: tonalities established by the relative opacity and transparency of the colors on the canvas. Torak mixes solvents and prepared mediums with her paints to increase their transparency and luminosity. The result is that her paintings appear to have veils of color flowing across the landscapes, still lifes, and figures, bathing the subjects in smoke, mist, and filtered light.

Torak looks to Peter Paul Rubens (1577–1640) for inspiration and technical information. She believes that one of the mediums she uses, Maroger medium, is close to what Rubens used. Maroger is a gelatin-like material that, when dry, suspends pigment in a hard, glass-like substance that permits natural light to penetrate and create a luminosity. Torak prepares the medium herself according to a tedious and potentially hazardous process, but there are a number of commercially made Maroger mediums available.

To give shape to an idea quickly, Torak makes an ink wash drawing on a sheet of colored paper.

Getting Started

The subjects of Torak's paintings are often inventions based on people and places that catch her attention. If those sights and events have the potential to be metaphors for something more significant, she tries to develop them into painting compositions by making sketches and color studies of the over- all composition and of individual parts of the scene. These preliminary stud- ies allow her to devise complicated arrangements of forms in which geomet- ric shapes and directional forces suggest the underlying theme of the picture. In the demonstration reproduced here, for example, she uses a spiral shape to mark the flow of light through the painting.

In going through a process of preliminary studies, Torak creates her pictures three separate times. The first two preliminary studies help her give concrete form to her notions, and the final painting on canvas allows her to present those carefully considered ideas to the viewer.

Palette

With the exception of an Old Holland-brand lead white, Torak prepares her own oil paints by grinding pigments and mixing them with light linseed oil. She lays out two rows of paints on her palette, one with pure colors and the other with grays that create a scale running from white to black. Each "note" of that scale is made of a gray mixed to the same value as its corresponding pure color. For example, cadmium yellow light will lie above a light gray of the same value.

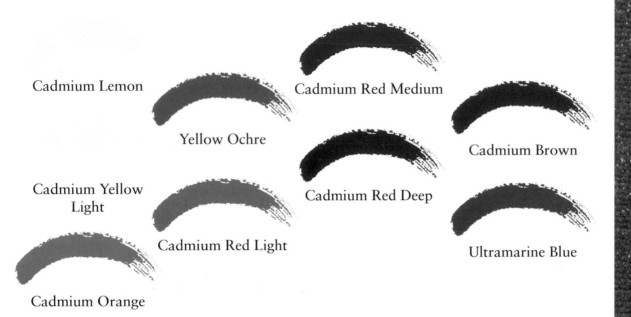

Cadmium Lemon

Cadmium Red Medium

Yellow Ochre

Cadmium Brown

Cadmium Yellow Light

Cadmium Red Deep

Cadmium Red Light

Ultramarine Blue

Cadmium Orange

Surface

Belgian linen sealed with rabbit-skin glue

Materials

Maroger medium
Traditional oil-painting medium
Bristle brushes
Small sable brushes (for finishing and drawing fine lines)

Torak says that the luminosity of her paintings depends on a smooth, light base that she prepares by sealing Belgian linen with rabbit-skin glue and then applying four coats of white lead paint with a palette knife. As a final preparation, she tones the surface with another coat of rabbit-skin glue mixed on the surface of the canvas with either a warm or a cool pigment, depending on her plan for the painting.

In addition to the Maroger medium, Torak uses a more traditional oil-painting medium made by combining one part damar varnish with one part turpentine and one part sun-thickened linseed oil. Most of the commercially made painting mediums on the market offer this combination of materials.

Preliminary Sketches and Color Studies

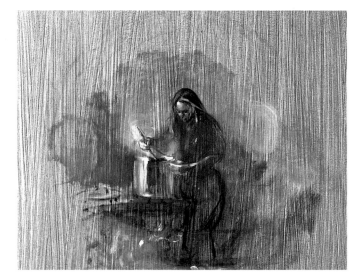

1 On a piece of toned canvas, Torak uses a few oil colors to make a color sketch of the idea. She doesn't have a model to use as reference, so there is little concern for the accuracy of the anatomy or lighting.

2 Charcoal is a good medium for making another quick study of the figure and soup kettle, as well as of the face of the woman in the picture. Torak uses herself as a model for the figure, but avoids making the drawing look like a self-portrait.

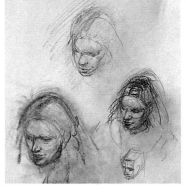

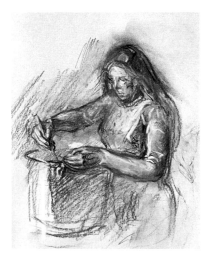

3 Because the carrots, celery, and broccoli might spoil during the weeks it will take to complete the large oil painting, the artist makes detailed sketches of them and the onions in a still-life composition to use later for reference. She is working with pastel and charcoal here.

4 She makes another ink-wash drawing of the complete composition and then imposes grid lines over the drawing to help in transferring the image onto the larger canvas used in the next step. This careful perspective drawing imposes structure on the earlier free-flowing composition studies.

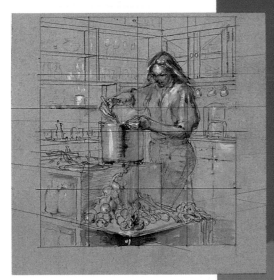

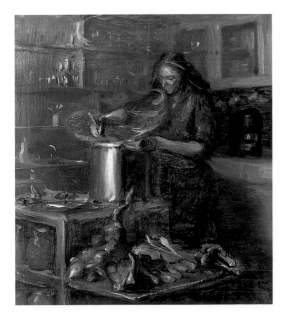

5 Torak focuses on the color, design, values, and light within the picture as she paints another color study in oil on a toned canvas. This exercise allows her to be freer and more deliberate when she begins working on the final painting.

FIGURE

Stages of the Painting Process

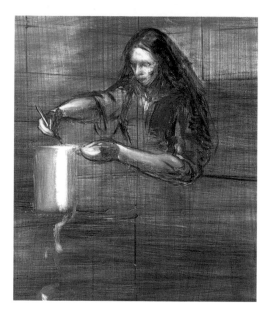

6 After drawing grid lines across the canvas at measured intervals, Torak redraws the lines of the perspective drawing in oil and blocks in the figure and soup kettle with broad gestures. She feels it is important to jump in and paint what is most important in a picture, beginning the process of building up opaque paint in that area.

7 Referring to her preliminary drawings, Torak paints the vegetables using colors thinned with turpentine.

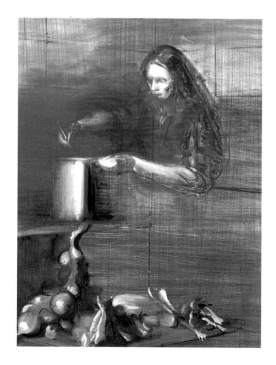

8 Torak applies a flat red paint to the blouse and then paints glazes of orange and blue over it to give a sense of dimension to the garment. She builds up the paint around the figure and vegetables so that the opacity will bring the viewer's attention to those elements. She also blocks in the cabinets in the background using thin mixtures of color and lead white.

9 Torak adds one of her two painting mediums to the oil colors to make thin glazes of paint. This mixture will bring definition to the objects in the picture without losing the luminous quality of the light within the imagined kitchen. Thin grays suggest the color of objects inside the kitchen cabinets.

10 With thin strokes of oil color, the artist now adds the jugs inside the cabinet and the dishes on the background shelves, using subtle shifts of value and opacity to describe the way light brings these objects to life. Torak further defines the figure, and the vegetable and jars in the foreground.

Completing the Painting

11 Torak uses glazes of paint mixed with Maroger medium to add flesh tones, give more definition to the steam, and add highlights to the cabinet doors. She allows each glaze to dry before applying another. The coffeepot is the only object for which Torak uses an actual object as a model; everything else is based on her memory or on an adaptation of some real utensil.

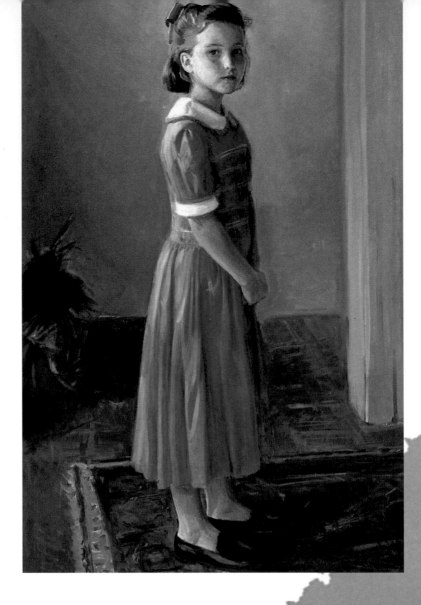

Portrait of Gabrielle

Oil, 40" x 34"
(101.6 cm x 86.4 cm)
Collection of Mr. & Mrs. Theodore DuBose Bratton

Joanette Hoffman Egeli studied at the Pennsylvania College of Art, Art Students League of New York, and the Cape School of Art. She is a cofounder of the Maryland Society of Portrait Painters and is a member of the Council of Leading American Portrait Painters.

Capturing a Likeness in Portraiture

Portrait painters may work with the same materials as still-life and landscape artists, but their enterprise is different in every other respect. In most cases, portraitists are hired to paint a subject based on their clients' specifications. The reward for accepting these conditions is the guaranteed sale of the painting at a price that is usually higher than for a comparably sized landscape, still life, or abstraction. Moreover, the artist has the opportunity to participate in an old and venerated artistic tradition.

Joanette Hoffman Egeli is a well-trained and nationally known portrait artist and a member of the Egeli family of Maryland, which has produced three generations of great painters. She and her husband, artist Cedric Egeli, both studied at the Art Students League in New York City and with the legendary artist Henry Hensche at the Cape School of Art in Provincetown, Massachusetts. Hensche taught his students how to understand and paint colors under different types of lighting. Joanette Hoffman Egeli applies that knowledge to painting sensitive, vibrant, and accurate portraits, especially of children.

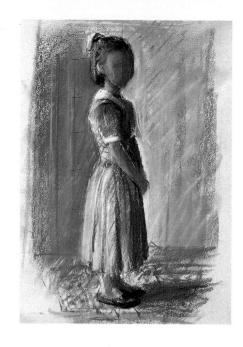

A pastel sketch to show the child's parents how Egeli plans to pose the child, handle the lighting, and place the Oriental rug that the mother requested be included in the picture.

Pastel drawing done to the size of the intended oil portrait.

Getting Started

One of the keys to painting a successful portrait is finding a pose and lighting that capture the sitter's personality. To achieve that, Egeli first spends time getting to know her subjects and evaluating the best place for painting. Her experience tells her that a child should always be illuminated by natural light coming from a source above the head or behind the figure. When she finds the best location, Egeli makes pastel sketches of the child in the pose she thinks will work and takes photographs for later reference.

If Egeli feels confident about the first sketch, she makes another pastel drawing on a sheet of paper the size of the intended oil portrait. She shows the full-scale drawing to the child's parents in the room where the portrait is likely to hang so they can make sure they like Egeli's overall plan for the painting.

Palette

Egeli's palette includes a selection of warm and cool colors that allow her to mix a variety of flesh tones as well as costume and background effects.

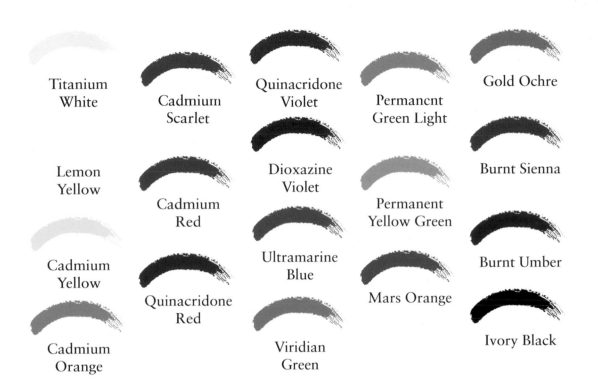

Titanium White

Cadmium Scarlet

Quinacridone Violet

Permanent Green Light

Gold Ochre

Lemon Yellow

Dioxazine Violet

Burnt Sienna

Cadmium Red

Cadmium Yellow

Permanent Yellow Green

Ultramarine Blue

Burnt Umber

Quinacridone Red

Cadmium Orange

Mars Orange

Viridian Green

Ivory Black

Surface

Finely woven Belgian linen canvas

Materials

Large and small bristle brushes
Soft sable brushes
Turpentine or mineral spirits (to thin colors)

Depending on the amount of texture she wants, Egeli uses either single- or double-primed Fredrix Antwerp canvas.

*P*ainting
Portrait of Gabrielle

1 Back in her Maryland studio with the 12" x 9" (30.5 cm x 22.9 cm) pastel sketch taped to the edge of the canvas for reference, Egeli sketches the figure in charcoal on a white canvas and applies spots of the appropriate color mixtures directly onto the canvas with a palette knife.

2 Now she uses thin mixtures of the colors to block in the figure's dress and the background. Egeli is using a large bristle brush and is thinning the paint with mineral spirits.

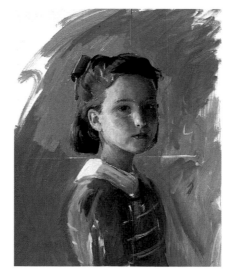

3 Because the face is the most critical part of the portrait, the artist concentrates on establishing a likeness in the depiction of the young girl's head. She also lightens the colors in the surrounding background, still keeping it a warm gray tone.

4 Returning to the clients' home, Egeli continues to refine the painting of the young girl's face and adjusts the hands and arms. She also adds some details to the dress and works on the rendering of the shoes.

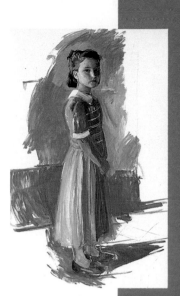

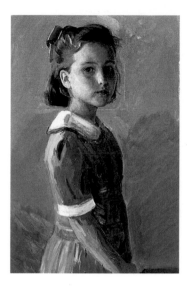

5 Now back in her studio, Egeli continues to build up the background tone and refine the painting of the girl's face. To allow herself plenty of time for blending tones within the face, she mixes a few drops of oil of cloves with her paints, which slows the drying time.

6 The child's mother brought two Oriental rugs that she wanted included in the painting, so Egeli adds them to the picture and finishes painting the child's feet.

Completing the Painting

7 Egeli feels the need for a vertical shape in the background that will correspond to the standing figure, so she paints the edge of a wall on the right-hand side. She adds details to the Oriental rugs and paints small refinements around the picture.

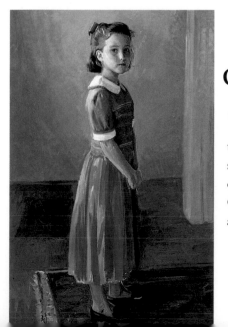

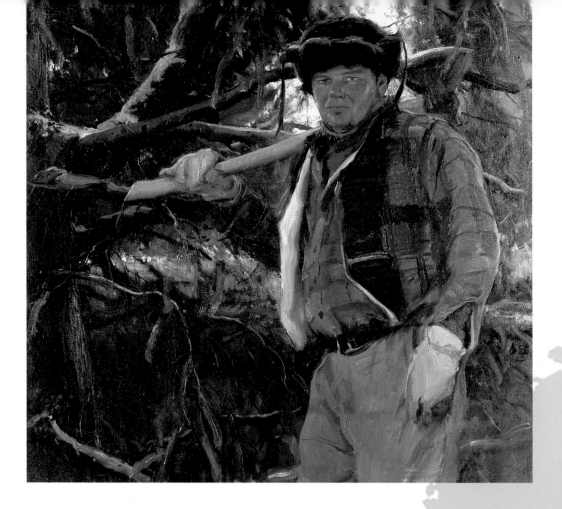

Northwest

Oil, 48" x 48"
(121.9 cm x 121.9 cm)
Private collection

As a high school student, Dan Gerhartz studied with John Bitinger, and he continued his
education at the American Academy of Art in Chicago under Bill Parks. In recent years,
Gerhartz has received the People's Choice Award, Buyer's Choice Award, and
Silver Medal at the National Academy of Western Art Show.

Recording Timeless Virtues

*A*rtists have the ability to create a world within the borders of their pictures. They can make social or political statements, interpret historic events, or capture a moment in time. Wisconsin artist Dan Gerhartz has a remarkable ability to present his views of life within large figurative oil paintings. By carefully choosing his models, the setting, and the lighting, he is able to create captivating scenes that celebrate the timelessness of romance, heritage, labor, family, youth, spirituality, and parenthood.

But Gerhartz isn't trying to persuade the viewer with blatant symbols. Rather, he simply paints the things that matter most to him personally—his family and friends living within the landscape they have occupied for generations. "I admire great artists of the past like Mucha, Fechin, Sorolla, Repin, and Carl Von Marr—artists who celebrated the full spectrum of human emotions," Gerhartz explains. With these artists as inspiration, he aspires to paint the joys and sorrows of the heart.

123

FIGURE

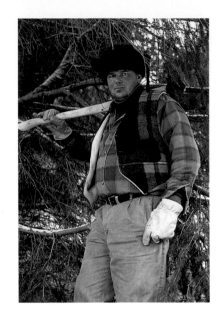

Photograph of the subject.

Working from a seated position so he can look up at his model, Gerhartz uses vine charcoal to draw the shape of the head and the shadows that define the eyes, nose, mouth, and chin.

Getting Started

Gerhartz most often uses live models, posing them in the barns, fields, and houses where they live in rural Wisconsin. Gerhartz first walks around the property looking for the setting and lighting that capture his feelings about the person. For example, when searching for the best place to pose his life-long friend, Craig Larsen, for the painting shown in this chapter, he happened to discover the perfect composition while kneeling down to pick his painting supplies up off the ground. From this low vantage point, Craig became the pioneering spirit Gerhartz imagined for his painting.

Working on a large, toned canvas set up on location, Gerhartz first sketches the figure with vine charcoal, focusing on accurate placement of shadow shapes rather than on individual features. He then uses large bristle brushes and a limited palette of oil colors to block in the pattern of values. His intention is to quickly establish the extremes of the lightest light and the darkest dark as well as the hardest and softest edges, which give him a basis of comparison as he refines the picture.

Palette

In recent years, Gerhartz has simplified his palette because he found he could accomplish more with a few colors than with many.

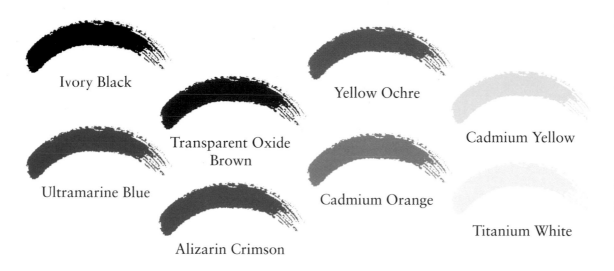

Ivory Black

Ultramarine Blue

Transparent Oxide Brown

Alizarin Crimson

Yellow Ochre

Cadmium Orange

Cadmium Yellow

Titanium White

Surface

Oil-primed linen canvas (medium textured)

Materials

Vine charcoal
Bristle brushes (large)
Turpentine (for thinning paint)

Just as he begins with the extremes of values and edges, Gerhartz takes a similar approach to dealing with color temperature. As early as possible in the process, he establishes the color extremes to help him judge the sensitivity of other color relationships. For example, in the painting of Craig Larsen, the fact that he established the brilliant red in the vest early on in the painting process made it easier for Gerhartz to key the rosy tones of the face. With the reference in place, he could make sure the facial tones didn't compete with the purity of hue on the vest. Instead of juxtaposing the extremes of warm and cool colors, Gerhartz prefers to develop subtle shifts between those temperatures, because the results are truer to natural light.

Painting
Northwest

1 After sketching the figure with vine charcoal, Gerhartz uses thinned paint to establish the middle-valued tone around the rest of the canvas. He leaves some white canvas on the left and right sides of the face to remind himself that the head should remain slightly darker in value than the background sky holes.

2 Now working with thin, dark paint, Gerhartz fills in the shape of the lumberman's hat and the line indicating the top edge of the axe he will hold on his shoulder. The model, Craig Larsen, works at a local dairy and is accustomed to being in cold temperatures for long periods of time.

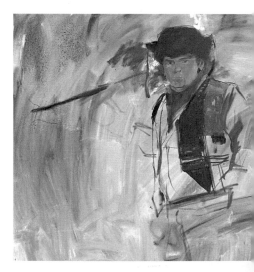

3 Continuing to focus on the figure, Gerhartz draws vertical lines to indicate the edges of Craig's vest and uses a broad stroke of paint to mark the waist. Working from the head down through the body, Gerhartz begins to fill in the clothing.

4 The artist now blocks in the figure's outstretched right arm and the broad axe that was once used to hew beams for the construction of barns and houses. He also adds detailed features to the face and hat.

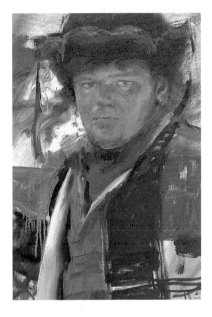

5 This detail of the face shows how Gerhartz balances the color and value of the face against the bright light in the background and the deep red in the vest.

Completing the Painting

6 Gerhartz paints the dark background with wide bristle brushes. He doesn't want the trees and bushes to have as much definition or detail as the figure, so he keeps those forms rather general and gestural.

Figure Gallery

Elizabeth Torak
The Haircut
16" x 18" (40.6 cm x 45.7 cm)

Elizabeth Torak
Attributes of the Artist
36" x 30" (91.4 cm x 76.2 cm)

Elizabeth Torak
The Watermelon Eaters
22" x 28" (55.9 cm x 71.1 cm)

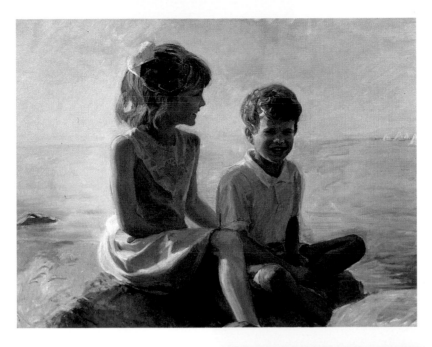

Joanette Hoffman Egeli
Paulson Children
36" x 46" (91.4 cm x 116.8 cm)

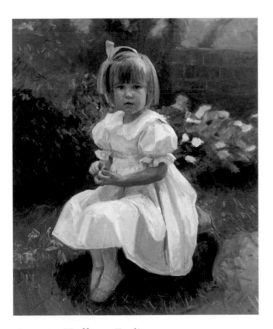

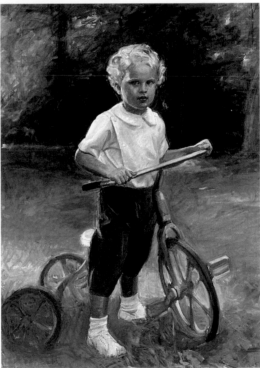

Joanette Hoffman Egeli
Ginna
38" x 32" (96.5 cm x 81.3 cm)

Joanette Hoffman Egeli
Portrait of Billy
46" x 34" (116.8 cm x 86.4 cm)

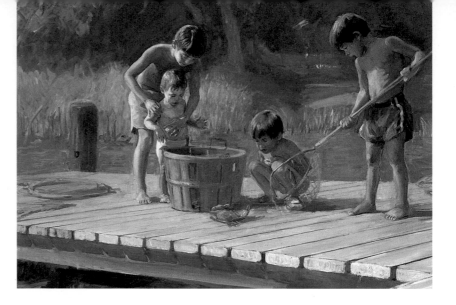

Joanette Hoffman Egeli
Ulep Children
36" x 48" (91.4 cm x 121.9 cm)

Dan Gerhartz
Jim
24" x 18" (61 cm x 45.7 cm)
Collection of Mr. & Mrs. James Ksioszk

Dan Gerhartz
Autumn Chores
60" x 48" (152.4 cm x 121.9 cm)
Private collection

Dan Gerhartz
The Simple Gift
60" x 40" (152.4 cm x 101.6 cm)
Collection of Mr. & Mrs. Jim Thompson

Dan Gerhartz
Alyssa
36" x 48" (91.4 cm x 121.9 cm)
Private collection

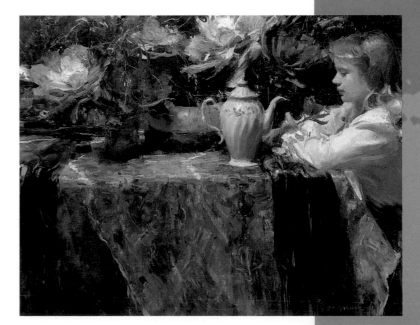

Contributors

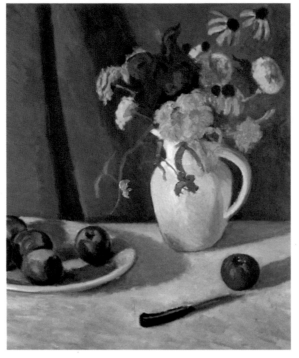

Joseph C. Skrapits
127 North Tenth Street
Allentown, PA 18202

William Michael Yenkevich
526 North Vine Street
Hazleton, PA 18201

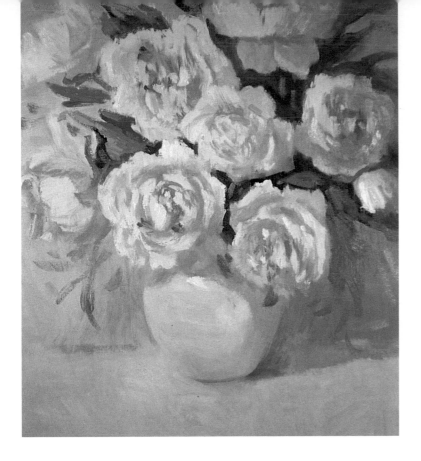

Sharon Burkett Kaiser
2880 Sea Ridge Drive
Malibu, CA 90265

Randall Lake
158 East 200 South
Suite 314
Salt Lake City, UT 84111

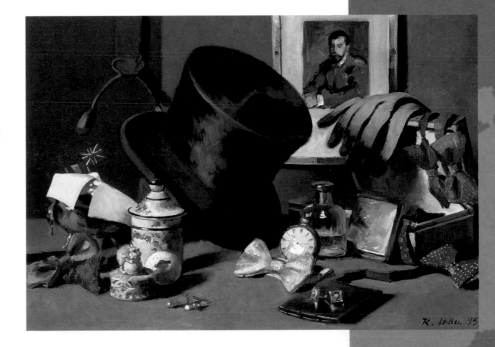

133

Dean Larson
1504 Park Avenue
Baltimore, MD 21217

Mary Anna Goetz
c/o The James Cox Gallery
26 Elwyn Lane
Woodstock, NY 12498

T. M. Nicholas
8R Apple Street
Essex, MA 01929

C. W. Mundy
8609 Manderly Drive
Indianapolis, IN 46240

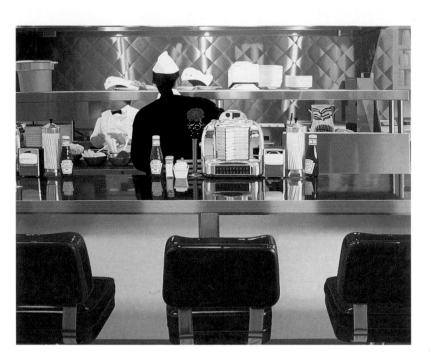

Robert Forbes
7720 Chesire Lane
St. Louis, MO 63123

Kent Wallis
155 Church Street
Logan, UT 84321

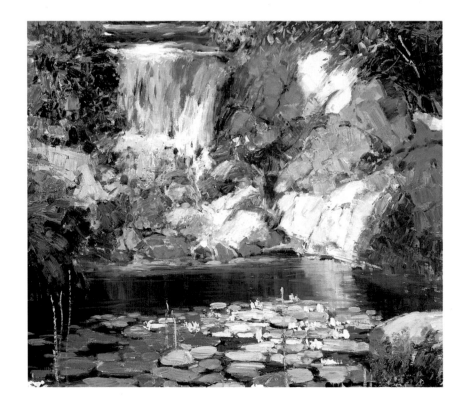

Michel Tombelaine
1623 Third Ave., Apt. 205
New York, NY 10128

Joseph McGurl
P.O. Box 797
Cataumet, MA 02534

137

Elizabeth Torak
Rt #1, Box 1823
Pawlet, VT 05761

Joanette Hoffman Egeli
Fiddler's Hill Road
Edgewater, MD 21037

Dan Gerhartz
W 832 Highway S
Kewaskum, WI 53040

CONTRIBUTORS

About the Author

M. Stephen Doherty is Editor-in-Chief of both *American Artist* and *Watercolor* magazines. He graduated summa cum laude and Phi Beta Kappa from Knox College in Galesburg, Illinois, and earned a Master of Fine Arts degree in printmaking from Cornell University. He is the author of numerous articles and books, including *Dynamic Still Lives in Watercolor, Developing Ideas in Artwork,* and *Business Letters for Artists.* Doherty recently presented solo exhibitions of his paintings and prints at Ferris State University in Michigan and the Bryant Galleries in New Orleans, Louisiana, and Jackson, Mississippi.

ABOUT THE AUTHOR